LEGENDARY LOCALS

OF

FOXBOROUGH

MASSACHUSETTS

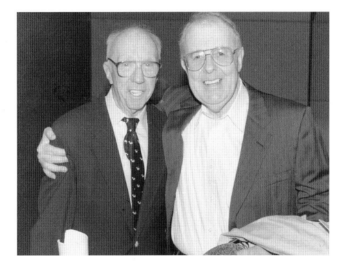

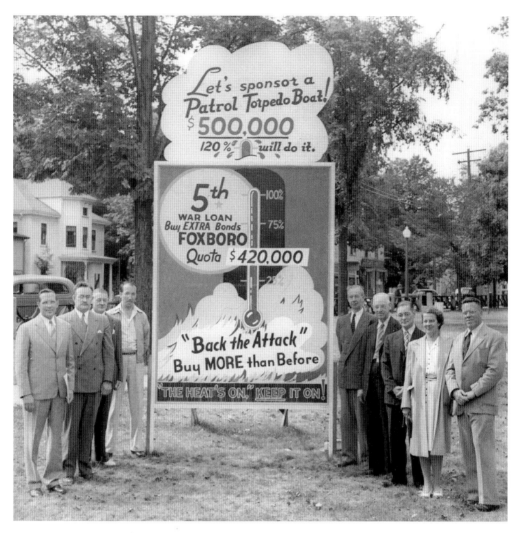

Community Mobilization

During World War II, civic leaders answered the call by directing a community mobilization that generated over $3 million through war bonds and stamp drives, enabling the purchase of two PT boats and 10 Thunderbolt fighter planes. Leading the charge were some of Foxboro's preeminent citizens—several of whom are recognized elsewhere in this book. From left to right are Corrie Fuller, Earle Sullivan, Dave Forbes, Bud Dudley, Wendall Dodge, F. Monroe Perry, Albert Hutchins, Louise Inman, and Massachusetts bond chairman Edward Burke. (Courtesy of Foxborough Historic Commission.)

Page 1: Vin Igo and Garrett Spillane

Even into their twilight years, local legends Vin Igo (left) and Garrett Spillane maintained a cherished friendship characterized by a common devotion to community. (Courtesy of *Foxboro Reporter*.)

LEGENDARY LOCALS

OF

FOXBOROUGH

MASSACHUSETTS

JEFFREY PETERSON

LEGENDARY
LOCALS

Legendary Locals is an imprint of Arcadia Publishing
Charleston, South Carolina

Printed in the United States of America

Library of Congress Control Number: 2013943851

For all general information, please contact Arcadia Publishing:
Telephone 843-853-2070
Fax 843-853-0044
E-mail sales@arcadiapublishing.com
For customer service and orders:
Toll-Free 1-888-313-2665

Visit us on the Internet at www.arcadiapublishing.com

Dedication
With eternal gratitude for my partner in life, Mary, and three special friends, Daniel, Sarah, and Jenny

On the Front Cover: Clockwise from top left:
Librarian Ruth Nowlan (Courtesy of *Foxboro Reporter*; see page 93), projectionist Bert Newell (Courtesy of Foxborough Historical Commission; see page 17), Foxboro Company founders E.H. and B.B. Bristol (Courtesy of Foxborough Historical Commission; see page 12), World War II veteran Russell Wheeler, Foxboro's first mail carrier (Courtesy of Foxborough Historical Commission; see page 71), businessman George Morrison (Courtesy of *Foxboro Reporter*; see page 59), National Football League (NFL) standout Tom Nalen (Courtesy of the *Sun Chronicle*; see page 100), firefighter Robert Lucas (Courtesy of *Foxboro Reporter*; see page 80), basketball prodigy Sarah Behn (Courtesy of *Foxboro Reporter*; see page 101), Marine Corps veteran Josephine Miller (Courtesy of *Foxboro Reporter*; see page 119).

On the Back Cover: From left to right:
General contractor and nonconformist Herbert Seltsam (Courtesy of *Foxboro Reporter*; see page 43), local newsman Vin Igo (Courtesy of *Foxboro Reporter*; see page 67).

CONTENTS

ACKNOWLEDGMENTS

Any list of acknowledgments for this book surely must begin with Jack Authelet, who urged me to accept this project and from whose own works all modern histories of Foxboro are derivative. In addition to providing a sounding board and hunting down key photographs, Jack's encyclopedic knowledge of his hometown (and mine) has been invaluable, not merely in the course of compiling this book, but on numerous occasions over the past 25 years. I also owe a debt of gratitude to members of the Foxboro Historical Commission, who not only granted permission to reproduce photographs in their collections, but also graciously accommodated repeated requests for access to town archives. A thank-you as well goes to Frank Mortimer, longtime reporter and photographer at the *Foxboro Reporter*, whose indefatigable work as a community journalist is reflected in many of the images and profiles sprinkled throughout these pages. Finally, I would be remiss in failing to recognize four individuals whose steadfast guidance and encouragement over the years exemplified the true spirit of Foxboro: Edward Cronin, Edward Devine, Vin Igo, and Charles Peterson.

Unless otherwise noted, all images are courtesy of the Foxboro Historical Commission or from the photograph archives at the *Foxboro Reporter* and the *Sun Chronicle*. Paul Beck and Stephen Massey (pages 16, 85), courtesy of Paula Bishop; Don Ahern and Walter Scott West (pages 104, 122), courtesy of Dorothy Ahern; E.M. Loew (page 19), courtesy of Brenda Loew; Bruce Congdon (page 51), courtesy of Glenda Haney; John and Helga Green (page 115), courtesy of Fred Green; Welsh's Dairy (page 56), courtesy of Patricia Welsh; John Certuse (page 94), courtesy of Adele Bonvie; Dr. Christiaan Khung (page 22), courtesy of Kathleen Khung from *Medical World News*, June 24, 1966; Frank Boyden (page 91), courtesy of Anne Lozier, Deerfield Academy Archives; Sanford S. Burr (page 123), courtesy of Rauner Special Collections Library at Dartmouth College; Rev. Frank Cary (page 118), courtesy of Amherst College Archives and Special Collections.

INTRODUCTION

If a picture truly is worth a thousand words, pictures that personify an individual's unique characteristics or accomplishments must be worth a king's ransom. At least, that is the proposition behind a pictorial attempt to relate the story of Foxboro through the hopes, dreams, and aspirations of its most recognizable citizens.

Settled in the 1600s and incorporated amidst the tumultuous Revolutionary years, Foxboro was, and is, a community rich in character and in characters. At the publisher's suggestion, this book is compiled by thematic chapters, with subjects categorized according by their most prominent experiences, features, or achievements. Needless to say such groupings are almost always subjective, and the diverse contributions of local luminaries could have been organized differently. Equally subjective were scores of decisions about who to include on the pages that follow, especially since the format by definition includes contemporary as well as historical figures. As much as possible, the aim has been identifying subjects with compelling stories accompanied by compelling images and who uniquely contributed to a shared vision of progress.

There is no shortage of more scholarly works chronicling the town's rich history, some of which provided invaluable anecdotal material for this effort. For those seeking information about Foxboro's first century, the definitive source remains Robert W. Carpenter's *Our Town*, written in 1890. Following in Carpenter's footsteps, Edith and Clifford Lane authored *This Was Foxboro*, published in 1966 (with a reprinting in the making). Two books were published in conjunction with the town's bicentennial in 1978, *Foxboro: A Pictorial History 1778–1978* and Jack Authelet's first book, *Glimpses of Early Foxboro*. Since then, Jack has authored four books examining Foxboro's past from a variety of perspectives, two of them produced by Arcadia Publishing.

It goes without saying that this volume is not intended as a comprehensive history, or even an exhaustive one. But inasmuch as history matters most when it is ours, it just may be possible to give readers a taste of what makes Foxboro a remarkable place.

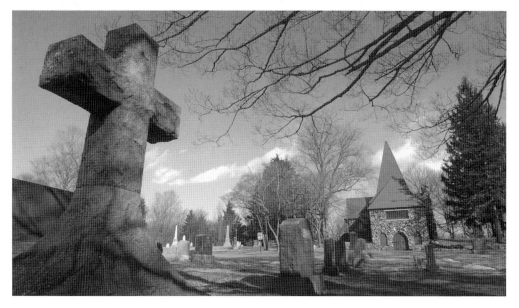

Rock Hill Cemetery
An imposing granite cross looms large with the Carpenter Memorial Chapel in the background at Rock Hill Cemetery.

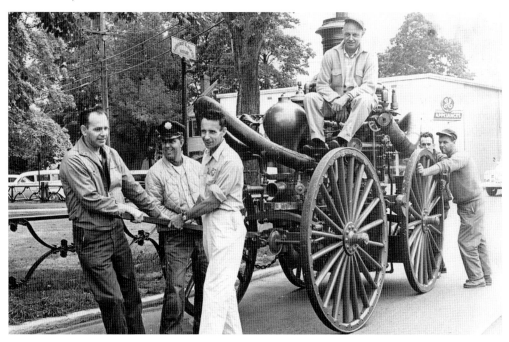

Fire Steamer
In the absence of available horsepower, old-fashioned sweat equity was needed to move the town's vintage horse-drawn fire steamer on ceremonial occasions. In this photograph, dated September 1962, Russ Wheeler, Art Reynolds, Walter Childs, Alison "Huck" Ellis, Bob Perkins, and Jack Jowett do the honors.

CHAPTER ONE

The Visionaries

Every journey begins with a vision, a spark of imagination to illuminate the frontiers of progress. And over the centuries, Foxboro has benefited from a panoply of visionary thinkers whose brilliant insights and willingness to take risks have delivered new opportunities and challenges. Collectively they have exerted an outsized influence on successive generations, fundamentally changing the face of Foxboro in ways both simple and profound and affecting the destinies of friends and neighbors alike.

The following 28 individuals personify the courage, commitment, and clarity of both thought and purpose that guided Foxboro's evolution from colonial-era village, to agricultural farm town, to manufacturing mecca, to modern bedroom suburb.

As one would expect, many of these legends were titans of private industry and commerce, industrialists from Foxboro's golden age of straw hat manufacturing or process controls instrumentation; some spent lifetimes working to improve the human condition, at home and abroad, or laying the foundation for a kinder and gentler community; while others brought a resolute single-mindedness to reshaping the landscape along the town's Route 1 corridor. And a handful pursued their dreams through a visual medium, hence the "visionary" connection.

But all shared a common bond: seizing a chance at greatness and pushing the transformative banner of progress forward. These are their stories.

Seth Boyden

Born on Oak Street in 1788, Seth Boyden was called "one of America's greatest inventors" by no less an authority than Thomas Edison. A mechanical genius, his inventive nature led him to discoveries in physics, art, chemistry, horticulture, and botany. While still a youth, he repaired watches, made his own telescope and microscope, painted in miniature, and invented a contraption for manufacturing wrought-iron nails and brads. Boyden married at 27 and relocated to Newark, New Jersey, where his creative instincts flourished and he developed leather-splitting machinery, a locomotive designed for the steep grades of the Morris & Essex Railroad, and a fire engine for the city of Newark. In addition, he helped Samuel Morse develop the telegraph, produced the first daguerreotype in America, and developed hybrid "Hilton" strawberries. Boyden died in 1879 in Hilton, New Jersey, and Newark later erected a monument in his honor.

E.P. Carpenter

Called "E.P." by most who knew him, Erastus Payson Carpenter was the rare visionary whose influence reached every corner of community life and continues to reverberate in Foxboro. Born in 1822, Carpenter was directly involved in virtually every major business deal and civic improvement from the mid-1850s to his death in 1902. Most notably, Carpenter in 1852 founded the Union Straw Works on Wall Street, uniting under one roof several smaller straw hat manufacturers to forge a global behemoth with a workforce exceeding 3,000 and cementing Foxboro's identity as "the straw hat capital of the world." A tireless civic booster, he established Foxboro's first fire department, underwrote construction of its first printing plant, and chaired the committee that built the magnificent Town House—using his own funds when the project ran over budget. He also convinced the state to purchase his Chestnut Street farm as a building site for the Foxboro State Hospital, which opened in 1893. In the early 1870s, Carpenter sold his stake in Union Straw Works to focus on new ventures and was named president of the Mansfield & Framingham, the Framingham & Lowell, and the Martha's Vineyard Railroads. For good measure, he was elected state senator in 1872, subsequently served in the House of Representatives, and was a town selectman for nine years. But for all his accomplishments, Carpenter's most enduring contribution remains the town Common, a focal point of civic pride and purpose even today. Although a public common previously had existed in Foxboro center, it was an unkempt, scrubby area bisected by what is now Route 140. The present rotary configuration with spoked sidewalks, all encircled by a wrought-iron fence, was laid out in 1857 by the Sylvanian Association, a private organization expressly created by Carpenter to design and execute the project. It was somehow fitting, then, that Carpenter was strolling across that same New England town green on January 31, 1902, when he collapsed and died. A simple marker—an inverted hat block in recognition of the industry he created—marks the spot where he fell, just to the right of the walkway leading toward Boyden Library.

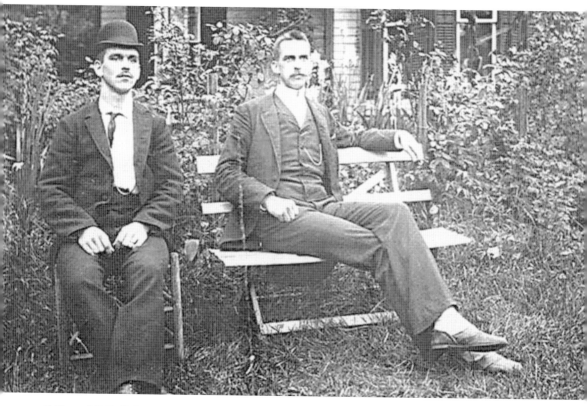

E.H. and B.B. Bristol

But for the vision and business acumen of Edgar H. and Bennet B. Bristol, Foxboro may never have fully recovered from twin disasters that seared its collective soul in 1900. With the town literally and figuratively in ruins after fires consumed the former Union Straw Works and Foxboro's magnificent Town House and the high school wing, the brothers Bristol in 1908 took a Syracuse, New York–based instrumentation company, moved into vacant industrial buildings on Neponset Avenue, and sowed the seeds of prosperity for much of the next century. In 1912, the firm adopted the Foxboro trademark and, two years later, changed its name to the Foxboro Company. With E.H. as president and B.B. clerk, the company quickly became the gold standard for gauges and instruments in manufacturing and process controls industry. In its heyday, the payroll topped 11,000 employees in 15 plants located in six countries. From the start, both brothers were directly involved in the business. During World War I, the company supplied air speed indicators for American planes, each tested by E.H. Bristol careening down Central Street in his DeTamble touring car while an assistant calibrated the unit by holding it aloft. But Foxboro gained more than an economic engine when the brothers set down roots here, and they married sisters: May Clarinda Rexford and Gertrude Allyn Rexford. Over the years, E.H. and B.B. served on numerous town boards and committees, providing the same direction and sense of purpose they displayed in business dealings. The measure of these men is best seen in a statement by B.B. Bristol, later enshrined as formal company policy: "Our policy is to have this place known far and wide as a good place to work. A place where everyone has a chance. Where every worker is paid the highest wages that can be paid and yet leave room for the business to be successful. To safeguard work just as far as it can be safeguarded. To recognize good work. And to appreciate the helpful assistance of every co-worker."

Rexford and Benjamin Bristol

As visionaries who planted the Foxboro Company banner here shortly after the turn of the century, E.H. Bristol and B.B. Bristol were a hard act to follow, but their respective sons Benjamin H. Bristol (right) and Rexford A. Bristol (left) remained faithful to that legacy after the deaths of the company founders in the early 1940s. In many ways, each of the cousins proved to be a chip off the old block. E.H. Bristol had been a mechanical genius who developed the recording and control instrumentation products; his son Ben displayed the same strengths. More outgoing, B.B. Bristol focused on community relations and outreach, a role his son Rex likewise embraced. Both had been groomed for management, with a top-rate education, real-work experience, and other preparatory steps, and they assumed the reins at a pivotal time. Stemming in part from the company's reliable performance during World War I, defense contracts poured in during World War II, doubling the payroll, prompting widespread hiring of women for the first time, and ushering in a period of unprecedented prosperity, both for the company and the community at large. Ben initially succeeded his father as company president, with Rex later succeeding his cousin. Both were sticklers for quality control and made substantial changes in machine shops and assembly lines to improve manufacturing quality and consistency. And like their fathers, the cousins were good citizens. Both were longtime trustees of Norwood Hospital and helped acquire the land that eventually became Foxborough Country Club. In addition, Ben Bristol was instrumental in creating the Foxborough Historical Society, while Rex donated land for the present-day Boyden Library at the corner of Bird and Baker Streets, donated the water rights to Lakeview Pond and the Upper Dam for conservation purposes, and served on Stadium Realty Trust, which built the original Schaefer Stadium in 1970.

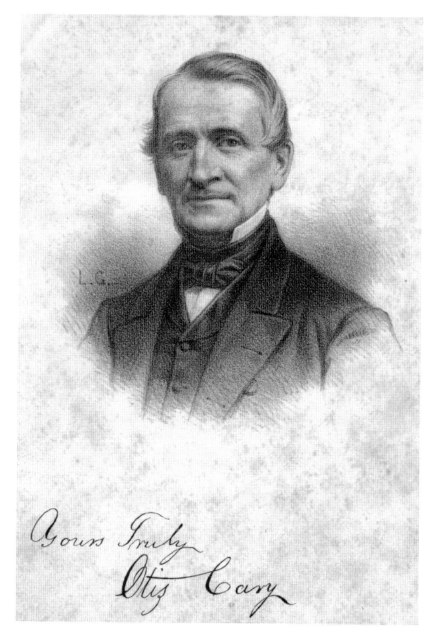

Otis Cary

One of the first industrialists to leave a mark on the community, Otis Cary owned an iron foundry in the early 1800s that manufactured, among other things, the iconic fence surrounding Foxboro Common. Born in Bridgewater, he settled in Foxboro and proved himself an enlightened employer as the first local businessman willing to hire Catholic immigrants. Cary also took seriously his civic duties, serving as a selectman, town moderator, and overseer of the poor, and was a key player in several notable institutions, including Rock Hill Cemetery, the Foxboro Branch Railroad Co., and Foxborough Savings Bank, which he started in 1855 with a $25 deposit, serving as its first president. Later, he was appointed to the committee of five, which provided the vision for a Civil War memorial building in the center of town, now Memorial Hall.

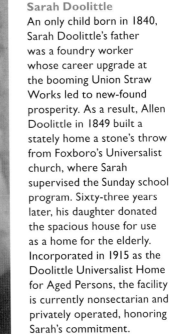

Sarah Doolittle
An only child born in 1840, Sarah Doolittle's father was a foundry worker whose career upgrade at the booming Union Straw Works led to new-found prosperity. As a result, Allen Doolittle in 1849 built a stately home a stone's throw from Foxboro's Universalist church, where Sarah supervised the Sunday school program. Sixty-three years later, his daughter donated the spacious house for use as a home for the elderly. Incorporated in 1915 as the Doolittle Universalist Home for Aged Persons, the facility is currently nonsectarian and privately operated, honoring Sarah's commitment.

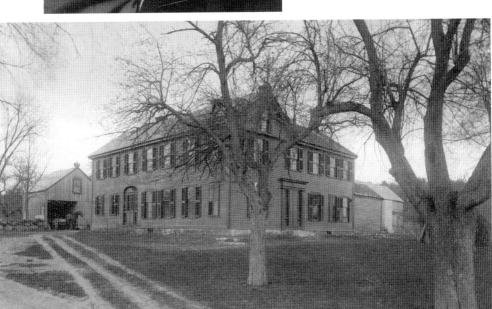

Virgil Pond
In his Market Street box factory, Virgil Pond made a fortune manufacturing shipping boxes for the straw hat industry. But his most lasting contribution remains the Pond Home, an elder care facility. In 1899, Pond's father, Gen. Lucas Pond, donated the original Pond Home in Norfolk (shown above) to the Kings Daughters & Sons of Norfolk County for elder care. Later, the enterprise was moved to the Sweat Estate on Route 140 in Wrentham where a new facility, still bearing the Pond name, was dedicated in 1934.

Paul Beck

Usually out of sight but rarely out of mind, Paul Beck deserves the title of "Captain Video" for helping develop local access television in Foxboro. A 1969 graduate and longtime employee of Emerson College, Beck joined Foxboro Cable Access in 1985, primarily as a technical consultant, and since then, he has had a formative role in videotaping and cablecasting local activities and events. But then, Beck always favored the view from behind the camera. While still in college, he worked part-time at WHDH-TV in Boston; his duties included operating the centerfield camera at Fenway Park during the 1967–1969 seasons, including the now legendary "Impossible Dream" summer. But arguably his most satisfying gig involved producing video documentaries for a railroad memorabilia show in Springfield, which was a sweet assignment for a kid who grew up next to the Readville railroad yards.

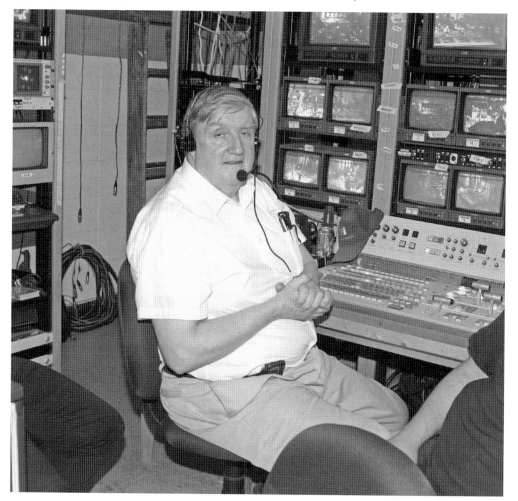

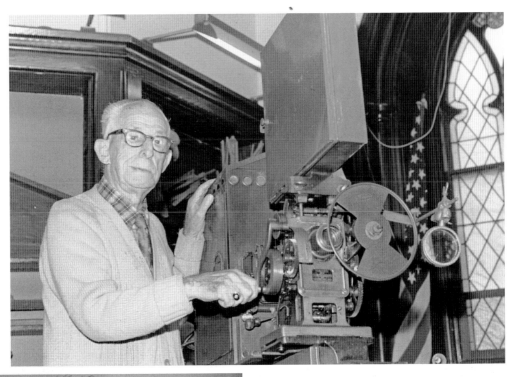

Bert Newell

Back when Foxboro kids could plunk down 25¢ and see two feature films, a newsreel, and coming attractions, Bert Newell ran the projector at the Orpheum Theater. He succeeded his father as projectionist at a theater in the old Union Building, which was razed when the Orpheum was built in 1927. To keep his job, Newell doubled as a driver for his boss's bus company and also served as the Orpheum's janitor. In 1983, he donated the old projector to the town museum at Memorial Hall, where it is still displayed.

Russell Harnden III

Russell Harnden III was bitten by the filmmaking bug in fourth grade after inheriting his grandmother's Super 8 camera. In junior high, he started making movies, and at Foxboro High School, he enrolled in the school's first-ever video production class. Best known for award-winning movie trailers and television campaigns, he currently works for Toy Box Entertainment as a senior editor and producer. A James Bond aficionado, Harnden cut the trailers for all four films starring Pierce Bronson: *Goldeneye*, *Tomorrow Never Dies*, *The World Is Not Enough*, and *Die Another Day*.

Edith and Cliff Lane

Edith and Clifford Lane's 1966 book *This Was Foxborough* was neither first nor last to trace the town's evolution from village to suburb, yet it galvanized interest in local preservation. The couple had seen much in their lifetimes. Edith's grandfather built the Paine School on Spring Street. Clifford personally witnessed the May 28, 1900, blaze which consumed the Union Straw Works, where his father was secretary-treasurer. Married 60 years, they were especially passionate about the town center and were gratified when Memorial Hall became home to the Foxborough Historical Commission.

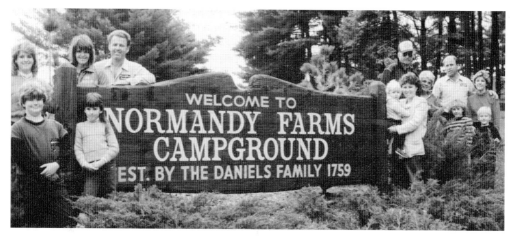

Francis Daniels

A French army officer imprisoned when King George's War roiled the colonies, Francois Guideau was later released to work at a farm in what is now South Foxboro. In 1759, having changed his name to Francis Daniels, he paid 67 pounds, 18 shillings for 53 acres, which he named Normandy Farm, a reminder of Normandy, France. Today, Daniels's seventh-, eighth- and ninth-generation descendants still live and work the West Street property, now home to a Christmas tree farm and Normandy Farms Campground, a five-star camping resort founded in 1971.

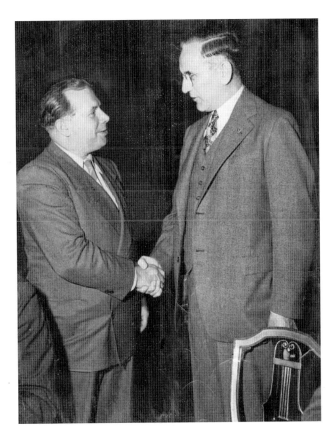

E.M. Loew

For one sufficiently preoccupied with far-flung business interests that he rarely even visited his local holdings, Elias Moses (E.M.) Loew, pictured at left greeting house speaker John McCormack, casts a long shadow in Foxboro. By happenstance or design, Loew, an entertainment magnate who owned movie theaters, drive-ins, hotels, and Latin Quarter nightclubs in both New York and Miami, made two decisions that forever changed Foxboro's destiny. First, at the close of World War II, with returning veterans desperate for entertainment options, he constructed a harness racing track on Route 1 in Foxboro, halfway between Boston and Providence. Known as Bay State Raceway, the track was a booming success, providing jobs and tax revenue for the town and drawing crowds from across southern New England. The second decision, two decades later, was even more far-reaching. Loew had been watching closely as Boston Patriots owner Billy Sullivan stalked the State House corridors seeking support to build a stadium at Neponset Circle for the soon-to-be-homeless Patriots. When the deal fell apart, Loew swiftly approached Foxboro selectmen and offered to sell (for $1) a parcel next to the raceway. It was a shrewd move. The gift parcel was just large enough for the stadium structure, and so, most of the parking would be on contiguous lots owned by Loew. Local voters—by a 1,852 to 84 margin—approved the proposal, and the rest is history. It was another victory for a compelling character. Just 13 when he left his family in Czernowitz, Austria, Loew first apprenticed to a watchmaker then waited tables at the famed Jacob Wirth restaurant in the city's Theater District. Incredibly, Loew was just 18 when he acquired his first property, the Crystal Movie Theater in Worcester. Not surprisingly, he enjoyed rubbing shoulders with celebrities, and his flamboyant lifestyle was tabloid fodder: Loew's first wife, Sonja, continued to live with him at his 40-acre Milton estate while his second wife, Mimi, lived in Connecticut. But he also had a conventional side. A Jew who moved to Milton, he built the B'nai Jacob Orthodox Shul on Blue Hills Parkway, and during World War II, he brought the rest of the Loew family from Vienna, probably saving them from Nazi death camps.

Billy Sullivan and Robert Kraft

One was a Lowell-born 1937 Boston College grad who tired of his $18-a-week sportswriter's job and became publicity director for Boston College, Notre Dame, and the Boston Braves baseball team. The other was the Harvard Business School–trained son of an observant Jewish dressmaker in Boston's Chinatown who wanted his son to be a rabbi. But at different times and in very different ways, both Billy Sullivan (opposite page) and Robert Kraft (below) shared a singular vision: operating a successful NFL franchise in suburban Foxboro. Sullivan was the quintessential dreamer who led a consortium of businessmen in securing the eighth and final AFL franchise in 1959. For a while, it was very much touch-and-go. Perennially short of cash, the fledgling Boston Patriots had no facility to call home, wandering between venues for a decade until Sullivan made a deal with Bay State Raceway owner E.M. Loew and relocated the franchise to a utilitarian stadium on Route 1—forever changing the face of Foxboro. Even then, the newly renamed New England Patriots remained a shoestring operation, beset by all manner of woes both on and off the field. By the late 1980s, Sullivan had lost both the football team and the stadium property to a series of transitional ownership interests, which were ultimately bought out by Kraft. A Patriots season-ticket holder since the opening of then Schaefer Stadium in 1971, Kraft was a multimillionaire paper/packaging executive who, like Sullivan, understood the potential of an NFL franchise. The difference was that Kraft had access to the investment capital necessary to execute his business plans. And after flirting with the notion of relocating the franchise, either to South Boston or Connecticut, he doubled down on the Foxboro site and constructed a privately financed, state-of-the-art stadium there. Maintaining a long-range vision, the Kraft Group has since acquired adjacent properties up and down Route 1 and erected Patriot Place, a four-season retail/entertainment complex adjacent to Gillette Stadium. Billy Sullivan died in 1998, never seeing his beloved Patriots win a Super Bowl title. But on the occasion of the team's 50th anniversary celebration, Kraft inducted the original owner into the Patriots Hall of Fame, saying, "Billy Sullivan made professional football a reality in New England. Without [him] the Patriots would not exist." In accompanying photographs, Sullivan looks over a scale model of Schaefer Stadium in 1969 while Kraft displays the 2012 AFC Championship Trophy.

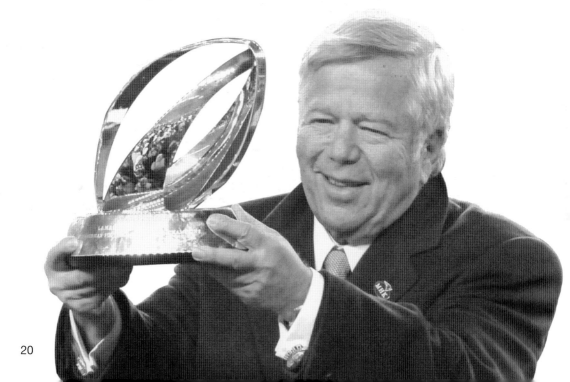

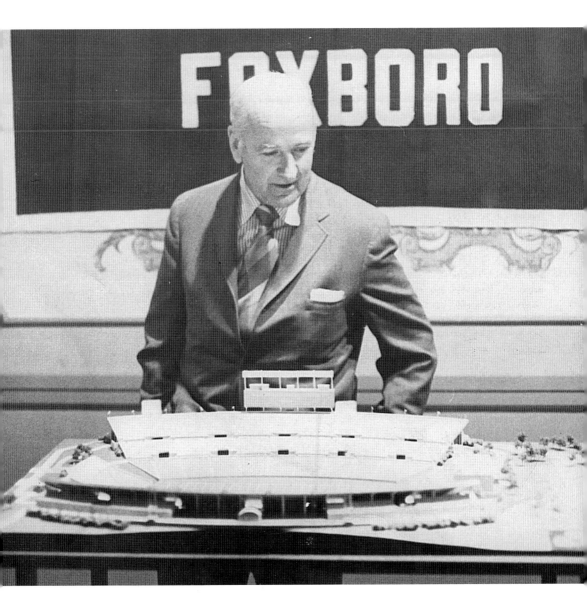

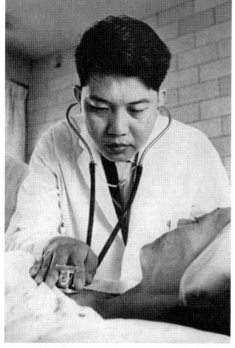

Dr. Christiaan Khung
Born in Java, Christiaan Khung joined the former Pondville Hospital in 1957 and launched a career that included fellowships at Harvard Medical School and the Jimmy Fund Foundation, appointments as chief of staff at Pondville and Sturdy Memorial Hospital, and a private practice in Foxboro. Despite these achievements Khung abruptly quit his practice in 1985, citing the cost of malpractice insurance. He later became associate medical director at Blue Cross Blue Shield, evaluating new procedures in day surgery as alternatives to hospitalization and riding the vanguard of an outpatient revolution that still resonates.

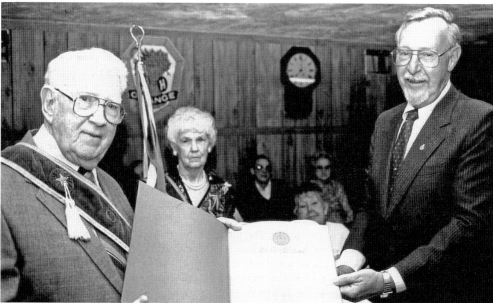

Sylvester "Whitey" VandenBoom
He was a former Navy Seabee and bowling alley manager who hatched a scheme to raise and sell vegetables for charity in 1990. Ever since, the Foxboro Community Farmstand has been part of Foxboro's summer landscape with Whitey VandenBoom its guiding spirit. Open seven days a week from July through October, the Foxboro Community Farmstand has raised nearly $350,000 for the Foxboro Discretionary Fund, a local assistance network. He is pictured on the right receiving the Foxboro Grange Citizen of the Year Award from Al Fitzpatrick in 1994.

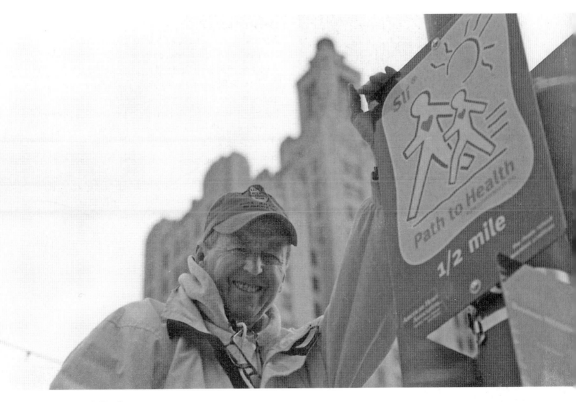

Dr. Richard Carleton

A grandson of Foxboro Company founder Bennett B. Bristol, Richard Carleton grew up in Foxboro feeling the weight of a family legacy. But as a specialist in cardiology and cardio-respiratory illnesses, Dr. Carleton created an impressive legacy all his own. Son of Russell and Margaret (Bristol) Carleton of Granite Street, he attended Foxboro High School, then graduated Deerfield Academy, Dartmouth College, and Harvard Medical School, the latter cum laude, and from 1960 to 1976, he held appointments at five hospitals across the country. Settling in Bristol, Rhode Island, he became chief of cardiology at Memorial Hospital in Pawtucket and served as the hospital's physician in chief from 1982 to 1995. Principal investigator of the federally funded Heart Health Project, from 1964 to 1999, Dr. Carleton served on or chaired more than 50 National Institutes of Health appointments and published more than 70 abstracts relating to his field. He was past president of the American Heart Association of Rhode Island, and in 1993, he received that organization's Golden Heart Award. He also held numerous academic appointments, including chairman of the medical department at Dartmouth Medical School and was professor emeritus at Brown University. Earlier in his career, Dr. Carleton was part of a 29-member team that collaborated on the second heart transplant undertaken at Presbyterian-St. Luke's Hospital in Chicago. In this case, the recipient was a boilermaker suffering progressive heart failure, while the donor was a construction worker mortally injured in an industrial accident. News reports at the time indicated the donated heart began beating within a minute after the heart-lung machine had been removed and said the recipient was so responsive he "almost sat up" for postoperative x-rays. In his free time, Dr. Carleton loved to sail. He was a fleet captain at the Barrington Yacht Club and, in 1991, was overall winner of the Bermuda Race. Years earlier, he placed first in the San Diego Yacht Club's Newport, California, to Ensenada, Mexico, race, and had also raced on the Great Lakes. Later in life, he also was devoted to the Path to Health program, a statewide initiative to increase physical activity and reduce heart disease, cancer, and diabetes. Dr. Carleton died in 2001, and the following year's annual Home & Hospice Care of Rhode Island Regatta was dedicated in his memory: "An avid sailor, hospice volunteer and patient."

Jerry Rodman

Outside the business community, few people noticed when two upstart brothers came to Foxboro in 1960, having acquired the Collier Ford dealership on Mechanic Street. But it did not take long for Don and Jerry Rodman to begin making their mark on a small town that, quite literally, has not been the same since. Theirs was a unique pairing—Don ran the business, and Jerry ran the town, or at least tried to. His wide-ranging civic activities included two separate stints on the board of selectmen, in the 1970s and then again in the 1990s; an extended tenure on the local housing authority; and a commitment bordering on devotion to the Friends of Foxboro Seniors. He loved calling the numbers at bingo games for local elders and personally led the charge to raise money for a permanent senior center, now located on Central Street. Generally acknowledged almost singularly responsible for bringing the New England Patriots to Foxboro in 1970, he was a charter member of the Foxboro Rotary Club, commander of American Legion Post 73, and an officer at Foxborough Savings Bank. An inveterate promoter who would go to any lengths for a good cause, including spending a day behind bars to raise money for muscular dystrophy research, Jerry was long the face of the Foxboro Discretionary Fund, the grassroots charitable network that he founded, which still evokes his spirit. Retiring from Rodman Ford in 1979 after a bout with cancer left his once hearty voice a raspy whisper, Jerry still had 20 years of public service left in him. At the time of his death at age 66 in March 1999, he became the only town selectman in over a century to die in office.

Don Rodman

Like his late brother, Don Rodman has come a long way since accepting the Ford Motor Company's offer to take over a small dealership in Foxboro more than 50 years ago. That business, Rodman Ford Sales, soon outgrew its Mechanic Street building and, in 1964, was relocated to a new site on Route 1, where the growth continued. In time, Rodman Ford acquired a Lincoln-Mercury franchise, followed by a second on Route 44 in Raynham; opened a specialized collision repair center; and even diversified into commercial real estate management and a health and fitness club. But as much as he accomplished in the car business (the Rodman holdings are now more modest, reflecting the ongoing contraction of the auto industry), Rodman has carved out an even greater legacy as a philanthropist. Best known for his annual fundraiser, the Rodman Ride for Kids, a charity bike ride to raise money for youth social services, Rodman has raised more than $71 million since the first ride in 1989. What started as a small, local charity event now attracts thousands of riders each year. Over the years, the Ride for Kids has grown to include other initiatives, including Celebration for Kids, the Marilyn Rodman Theatre for Kids Program, Disney for Kids, and Car Donations for Kids. In 2007, he bought out the Colonial Theatre so disadvantaged kids could experience a live performance, then followed it up by sending 1,500 inner-city kids to Disney World. Given the designation of knight by Pope John Paul II, he was awarded honorary doctorates by University of Massachusetts, Curry College, and Suffolk University. Not bad for a Dorchester kid who loved cars so much he enlisted in the Army just to work as a mechanic.

Hoel Bowditch

Like many who made the Foxboro Company a beehive of creativity, Hoel Bowditch was blessed with a curious mind. Decades before "innovation" became de rigueur among business leaders, he was an expert in process control instrumentation with more than 75 patents. Bowditch also was a pillar at St. Mark's Church, which encountered his creative side when a huge outdoor cross needed replacing. Ignoring the contractor's pleas for a crane, Bowditch designed an intricate system of ropes and pulleys enabling parishioners to collectively hoist the new version into place.

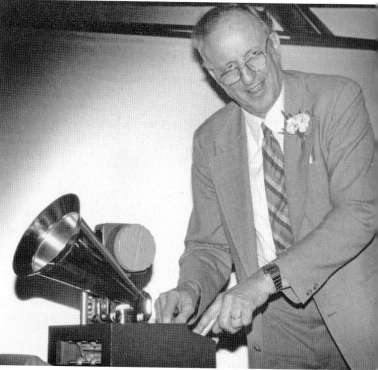

Archie Hanna

Multitalented with the ability to fix just about anything, Archibald "Archie" Hanna's fingerprints remain, most notably, on the ornamental Civil War–era wrought-iron fence circling the town Common. By 1971, numerous sections had been damaged and could not be replaced without new cast-iron molds. Hanna took impressions of existing fence sections and fashioned epoxy reproductions that cured in his wife's oven. The methods may have been unconventional, but the results perfectly satisfactory. Though Hanna died in 1996, his 1971 fence mold is still used to create replacement sections when the need arises.

Orlando McKenzie

Orlando McKenzie demonstrated a shrewd eye in 1905 when he purchased a blacksmith shop on Central Street. Apparently, he possessed a device to bond rubber tires onto buggy wheels—a distinct advantage over competitors who could service horse or wagon but not both. Later, he sold Oldsmobiles and was committed to civic affairs, serving as a state legislator and local selectman. Just 52 when he died in 1920, the business passed on to sons Russell and Harold, who jettisoned Oldsmobile in favor of a Chevrolet franchise that lasted four decades.

Vince O'Neill

A Boston-based developer who specializes in overhauling architecturally significant industrial sites, Vince O'Neill was unknown in Foxboro before 2005 when he unveiled a sweeping vision for the crumbling Foxboro State Hospital campus. Certain that tenants would queue up for exposed brick-and-beam ambiance, even in the suburbs, O'Neill paid $4.7 million for the 19th-century landmarks, gutting interiors while preserving the iconic skyline along Chestnut Street. Setbacks included a major construction fire and grinding recession, but O'Neill delivered on most of his promises.

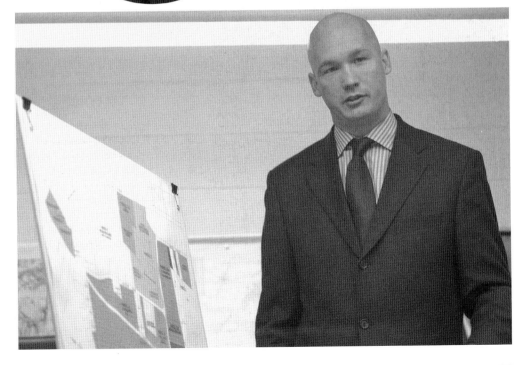

Homer White

Had Norman Rockwell lived in Foxboro, his name would have been Homer White. Born on Quaker Hill in South Foxboro, White was a greeting card illustrator who later became the town's unofficial artist-in-residence, selling paintings from the local community club on Saturday mornings. His most memorable works were historic scenes that, even today, grace many local businesses and private homes. Quintessentially Foxboro, White's artistic vision reflected his hometown—a sentiment reflected on his grave marker at Rock Hill Cemetery: "Because he lived many eyes saw beauty."

William Jobin

A man of two worlds, William Jobin worked on tropical disease control in Puerto Rico, surveyed polluted rivers in Massachusetts, and in 1979, moved with his family to Sudan, where he witnessed the afflictions of malaria and other parasitic diseases. From that five-year experience, Jobin helped jump-start a $150-million project to control malaria in Sudan and, in 1984, formed Blue Nile Associates, a global consulting group specializing in health and environmental impacts of large water and energy projects.

CHAPTER TWO

The Personalities

While propriety has its place, charisma is a lot more memorable. And so it has always been in Foxboro, where an indelible pantheon of outsized personalities, quirky characters, and larger-than-life luminaries has marched to the beats of their different drummers while adding a rich dimension to community life and, paradoxically, helping define a common identity. Some lovable, others exasperating, all unforgettable, these rogues and rascals included merchants, businessmen, civic leaders, entertainers, car dealers, and even professional athletes from a wide variety of backgrounds and circumstances.

While some of these notables have made their names beyond Foxboro's borders, most remain household names locally, and deservedly so. Who can forget—or would ever want to—the provincially convivial Norm Lawton, self-styled hayseed, born entrepreneur, and benevolent mentor to thousands of 4-H members; local attorney Harold Cohen, a pugnacious war hero who flew with Ted Williams and championed the county agricultural school; highway chief Al Truax, eliciting groans from town meeting voters while launching into yet another manifesto with characteristic staccato precision; patrolman Billy Graham, the burly police sergeant who doubled as a clinical hypnotist; general contractor Herb Seltsam, amiable nonconformist cast as villainous junk dealer; or lanky Gene Conley, longtime businessman with a remarkable athletic pedigree.

Whether irritating or entertaining, these individuals provided their share of memorable moments over the years. These are their stories.

Leo and Alma Conway
For decades Leo and Alma Conway, known affectionately as "Ma and Pa Conway," were the straw that stirred the drink in West Foxboro. Each August, crowds at the annual fireman's parade awaited Alma's entrance on the West Foxboro Mother's Club float, typically sporting an old-fashioned bathing suit secured by red suspenders over long underwear. In 1978, her shining moment came when she was elected Foxboro's bicentennial "mayor." With Leo as consort, Alma was grand dame of an eventful summer.

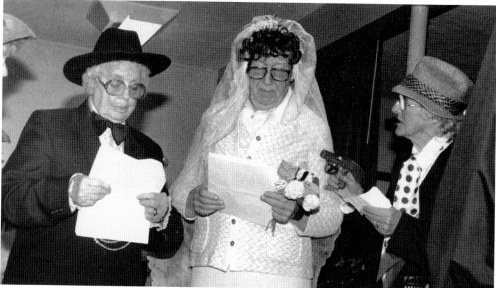

Al and Ethel Fitzpatrick
Remembered fundamentally as mainstays of the Foxboro Grange, Al and Ethel Fitzpatrick helped keep the once-vibrant organization relevant in its final years by coordinating a Citizen of the Year recognition program. Yet with a name like Fitzpatrick, it is no surprise the couple had a gift for blarney and was always ready for some good-natured fun. Pictured in a memorable "Shotgun Wedding" skit from a Grange theatrical, Al (center) played the bride with Ethel (left) as his groom. Lillian Rawcliffe, pistol in hand, was the parson.

Orville Davis

H. Orville Davis might not have had ink in his veins, but he had plenty on his hands, having spent much of his life in the newspaper distribution business. Starting as a paperboy in 1927, he later graduated to part-time clerk at Charlie Prew's news store on Central Street. Davis purchased the business in 1952, and for three decades, Orville's News was a fixture in downtown Foxboro. But Davis also was born with a silver tongue, which he utilized during a parallel career as a highly regarded auctioneer. His was a familiar voice at many auctions, but especially at Foxboro's annual "Jimmy Fund Auction," held each year on the common. He also served on numerous town boards and even chaired the Democratic Town Committee. More pivotally, Davis chaired the Foxboro Housing Authority with his efforts contributing to the Centennial Court and Annon Court complexes.

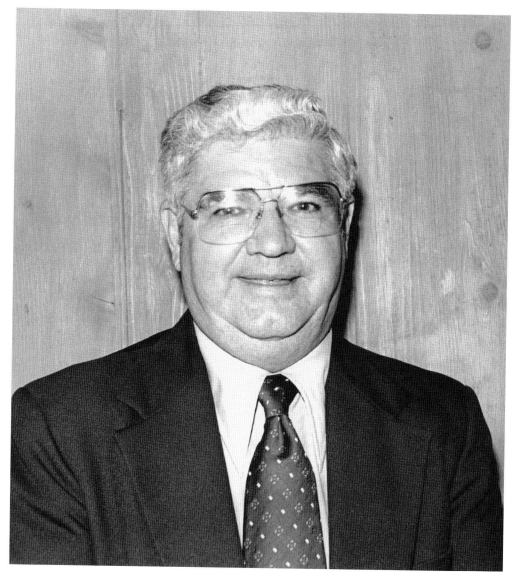

Harold Donnelly

Temperamentally predisposed to a bark worse than his bite, Harold Donnelly did not merely engage in conversation—he dominated it. A Marine who served during the Korean War, he remained faithful to the Corps his entire life. Not surprisingly, he also retained a drill instructor's approach to problem solving: frank, direct, and quite often, loud. But the abrasive exterior masked a generous nature. Donnelly and his wife, Toni, were among scores of families who left Boston's inner suburbs for ready-built neighborhoods in Foxboro, determined to leave a mark on their new hometown. A Boston College graduate who brought a leather-lunged coaching style to youth hockey games, he was equally passionate about civic duties, serving on the Foxboro Housing Authority for 35 years. Shortly after his death in May 2011, a special garden area was dedicated in his honor at the Annon Court senior housing complex.

Edward Devine

"Brothers and sisters I have none, but that man's father is my father's son." It was Ed Devine's signature brainteaser, which he delighted in repeating for generations of perplexed youngsters. Few arrived at the correct answer. One of seven children growing up on a Chestnut Street farm during the Depression, Devine considered himself lucky: times were hard, but there was always food on the table. Maybe that is what connected him to the old farm, which became a family compound as various descendants built homes on the property. A 1938 graduate of Foxboro High School, Devine had worked as a machinist at the Foxboro Company during World War II, manufacturing guidance systems for torpedoes, and was a call firefighter in the days when volunteers supplanted a small full-time force. But his first love was cars, and he operated a garage and filling station on a Central Street site now occupied by the Foxboro Mobil station. In the 1960s, he renamed the business Devine's Motor Sales and moved across the street, where a new Lincoln-Mercury dealership was built (the complex was later converted for use as professional offices). After losing the business, Devine continued to repair cars in a garage next to his Chestnut Street home stocked with an array of tools and equipment salvaged over the years. He always had time to share a drink with passers-by who dropped in unannounced. And he always loved hosting chowder (strictly Manhattan-style) parties in his basement for friends and extended family. During these affairs, he would sit by the stove frying batches of clam cakes while lording over the proceedings until guests, content after multiple bowls, would disperse.

Demetri and Nick Panagopolous
In the dog-eat-dog restaurant business, where periodic reinvention is key to success, few have been better longer than two Greek brothers, Demetri (right) and Nick (left) Panagopolous. Since acquiring their Route 1 property in 1970, they have undertaken numerous makeovers to remain competitive—from the Red Snapper to Funway Café, several steak houses, and nightclubs. They are pictured with their late father, Hercules, the inspiration for Hercules Plaza at the corner of Route 1 and Water Street.

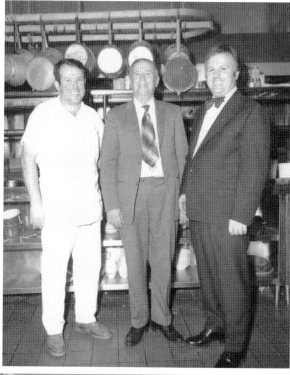

Dr. Alan Lee
In four decades practicing dentistry in Foxboro, Alan Lee's reservoir of jokes and funny stories have become part of the ritual accompanying a six-month checkup—a uniquely personal touch with an extended family of patients. A Norwood native who graduated from Holy Cross and the University of Maryland Dental School, Lee remains fiercely loyal to his staff and the New England Patriots, indulging both at every opportunity.

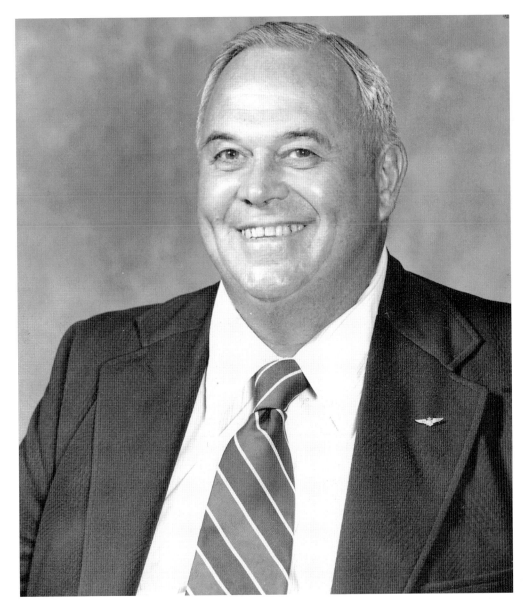

Bob Conkey

Formidable in both stature and temperament, Bob Conkey had an eye for the next deal and found it in the late 1960s with a business venture perfectly timed to catch the latest wave in suburban culture: backyard swimming pools. A Navy pilot who flew B-24s in the Pacific during World War II, Conkey intuitively grasped that inexpensive aboveground models put backyard pools within reach of middle-class families and launched a business from his East Street barn selling and installing them. It was a shrewd venture, and at times, he could scarcely keep up with demand. Conkey also had an itch for politics, and in 1975, he ran for a selectman's seat. He bested opponent Carole Burns by a narrow margin and even attended one board meeting, but Burns filed for a recount, and the results were reversed. Conkey gained a measure of political satisfaction years later when elected mayor of Briny Breezes, a Florida retirement community. Then 77-year-old Conkey defeated his lone opponent, an 83-year-old neighbor, after reportedly spending just $11 on campaign expenses.

Betty Friedmann
A New England Patriots stockholder long before the move to Foxboro, Betty Friedmann remained a fan until her death in 2004 at age 93. Widowed decades earlier, the Smith College graduate who lived alone in a tiny Central Street flat also was a keen student of local affairs. Her shining moment came in December 1999: before thousands of residents and banks of television cameras, Friedmann was singled out to call the momentous vote authorizing construction of Gillette Stadium—preserving the Patriots/Foxboro connection.

Francis "Bucko" Kilroy
One of many transplants with ties to the New England Patriots, Francis "Bucko" Kilroy lived in town 37 years until his death in 2007. A merchant mariner during World War II, Kilroy served the Patriots in numerous front-office positions. He also played 13 NFL seasons for the Philadelphia Eagles, earning a reputation as a brutally tough player in what was then a no-holds-barred league. In fact, *Life* magazine in 1955 labeled him the NFL's dirtiest player, prompting a libel suit, which netted Kilroy a $25,000 jury award.

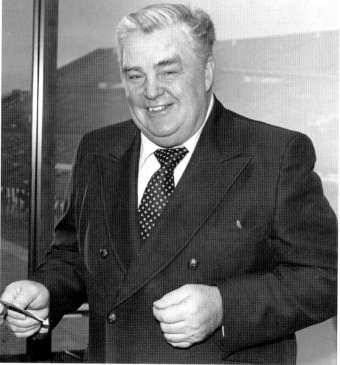

Rudolph Schulz

Rudolph Schulz was 80 on May 13, 2009, when a garden hose–toting neighbor knocked on the door to inform him his house was on fire. The two-story home, hard against log piles cluttering his Green Street lumberyard and sawmill, was later razed and replaced with a new structure. For Schulz, it was a minor setback. Raised during the Great Depression, he left school in sixth grade to work his grandfather's 300-acre dairy farm on what is now the nearby Mansfield industrial park. Despite a lack of formal schooling, Schulz grew up in a family of self-reliant tradesmen. A bulldozer fabricated by adding a blade to an old farm tractor became his primary source of income when raising his five children. Another project, an airplane built from scratch with his father, Walter H. Schulz, but never finished, was converted a generation later to a propeller-drive iceboat that used to careen across Gavin's Pond with his teenage sons Dan and Rudy Jr. at the helm. Such creativity notwithstanding, Schulz was always defined by the sawmill, which supplied rough-cut lumber to specialty builders and craftsmen. Featured in a 1989 photograph spread in the *Foxboro Reporter*, the mill, inherited from his father, was powered by a 248-cubic inch GMC engine and used 52-inch and 49-inch upper and lower circular blades to slice huge planks and beams. Though partially disabled and unable to raise his left arm above the shoulder, Schulz operated the mill alone. He never advertised his services or purchased raw logs—people just called and dumped them off—and he confessed to turning away 90 percent of prospective customers, knowing he would never quite get around to filling their orders.

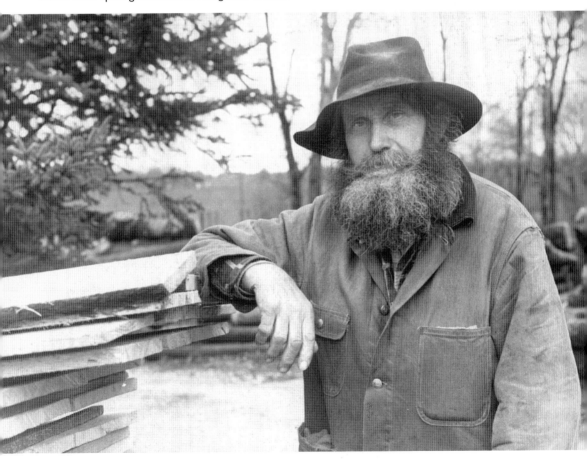

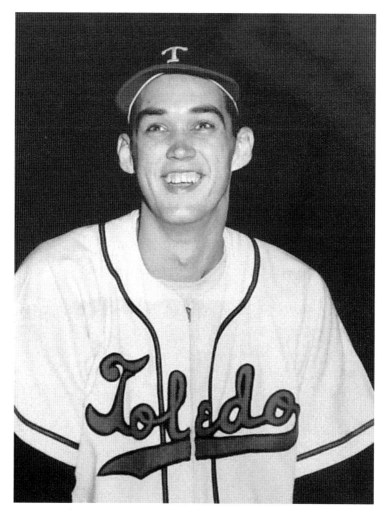

Gene Conley
In the annals of sports trivia, Gene Conley's legacy looms longer even than his lanky six-foot, eight-inch frame. Conley, who moved to Foxboro in 1960 with his wife, Katie, occupies a unique place in sports history as the only professional athlete to play for three teams from the same city: the Boston Braves, Boston Red Sox, and Boston Celtics. He also is the sole athlete to win championships in two professional sports—a 1957 World Series win with the Milwaukee Braves and three titles with the Celtics—and was teammates with four hall-of-famers: Ted Williams, Hank Aaron, Bill Russell, and Bob Cousy. He was also the winning pitcher in the 1955 MLB All-Star Game. Born in Muskogee, Oklahoma, he was raised in Washington and played baseball and basketball at Washington State University before signing a professional contract with the Boston Braves. Excused from service in the Korean War because his height exceeded the Army maximum, Conley was called up to the big leagues in 1952 and made the Celtics that same year after being recommended to manager Red Auerbach by guard Bill Sharman. Of course, Conley figured in one of the celebrated chapters in Boston sports lore: going AWOL with teammate Pumpsie Green (the Red Sox's first black player) following a 13-3 rout at Yankee Stadium in July 1962. The escapade led to a $1,500 fine when the red-faced Conley eventually returned to the team several days later. Just 33 years old when he hung up his spikes and sneakers, Conley initially worked as a salesman before launching the Foxboro Paper Co. in 1965—a business he and Katie operated for the next 35 years.

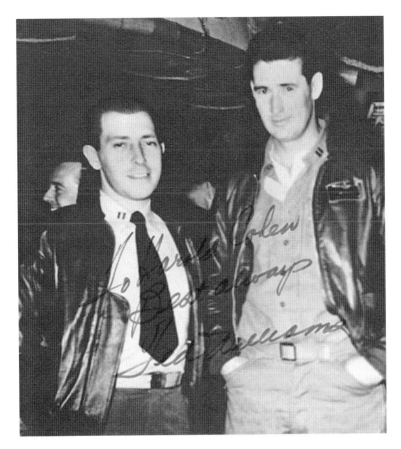

Harold Cohen

Beyond the Mutt-and-Jeff height differential, Harold Cohen (left) had much in common with Red Sox slugger Ted Williams, his flight-training buddy and fellow Korean War pilot. Both were brash, self-assured, and bracingly profane when circumstances warranted (and sometimes when they did not). And both personified America's "Greatest Generation," eventually becoming legitimate hall-of-famers in their respective professions. Born and raised in Dorchester, Cohen was 18 in 1942 when he enlisted in the Navy. He earned his wings in 1944 and was assigned to escort patrol duty on a PBY flying boat in the Pacific, rising to the rank of lieutenant commander by war's end. After his discharge in 1948, Cohen earned an undergraduate degree and was studying at Suffolk Law School when recalled to active duty as hostilities in Korea broke out. Later returning stateside for good, Cohen passed the bar and opened a practice in Foxboro. Among his clients were the New England Patriots; Cohen was instrumental in handling the sale of the franchise for then-owner Billy Sullivan. A passionate advocate for the legal system, he was appointed assistant attorney general in Massachusetts, assistant district attorney in Norfolk County, and even argued a case before the US Supreme Court. In addition to his trial caseload, Cohen frequently represented clients before municipal boards in Foxboro and was fiercely proud of the Norfolk County Agricultural High School, where he chaired the board of trustees for more than 30 years. A charter member of Foxboro Rotary, he also was a long-serving director of New England Sinai Hospital, a director and past president of Suffolk Law School, and a member of the National Alumni Law Association. Two years before his death in April 2012, Cohen was among a group of Pacific war veterans chosen to attend an HBO-sponsored ceremony at the National World War II Memorial in Washington, DC. The gathering coincided with the release of the HBO miniseries *The Pacific*, produced by Steven Spielberg and Tom Hanks, who were on hand to personally thank the aging veterans. "It brings back a lot of memories—you lose so many good friends," he said.

Myrtle Murphy

Living at the old Van Dora Nursing Home, Myrtle Murphy was instantly recognizable on her daily rambles about town. Like clockwork, she walked to morning mass at nearby St. Mary's Church and then set off on her rounds. A Hyde Park native, Murphy was one of 50 Van Dora residents displaced in October 2000 when regulators closed the insolvent facility. But before she relocated, civic and business leaders threw a farewell party in her honor. Serene and happy as the center of attention, Murphy, who died in January 2010, observed that, in Foxboro, "everybody loves me."

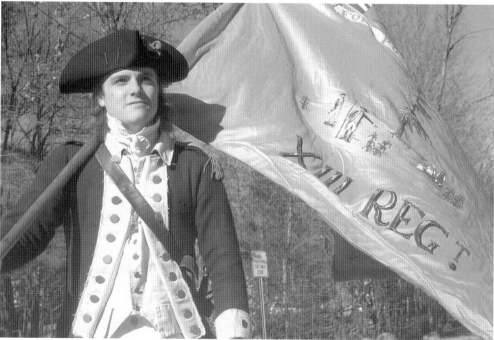

Tom Dietzel

Sporting a tricornered hat, period clothing, and toting a musket, Tom Dietzel indulges his passion for colonial history as a period reenactor. A guide conducting walking tours on Boston's Freedom Trail, Dietzel is also an ensign in the 13th Continental Regiment, participates in annual reenactments of the Boston Tea Party and Boston Massacre, and celebrates touchdowns at Gillette Stadium as a member of the New England Patriots' "End Zone Militia."

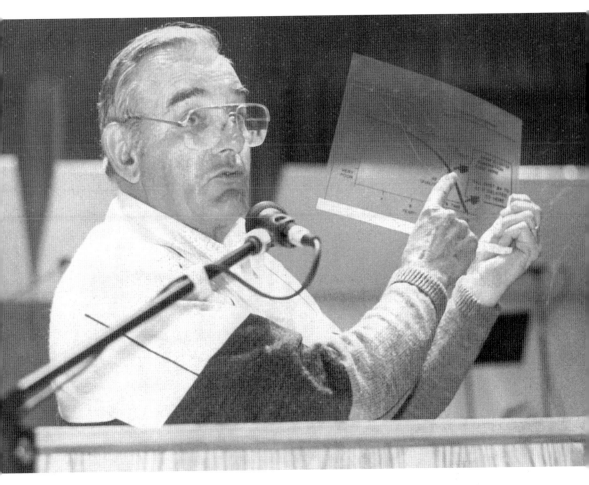

Al Truax

If anyone deserved the title of Foxboro's favorite curmudgeon, it was highway superintendent Al Truax. A hometown boy, Truax knew the town's roadway grid backwards and forwards when he got the job in 1967, and over the next 24 years, motorists and taxpayers alike appreciated his superbly efficient snow-removal campaigns. To the faint-hearted, Truax was feisty and combative with a nose for waste, at least when in someone else's budget, and could be a thorn in the side of colleagues he judged profligate. No town meeting was complete without at least one lecture from an agitated Truax, overwhelming the opposition with statistics while eliciting groans from clock-watchers who feared his remarks would push adjournment beyond the witching hour. However, Truax's instincts were generally sound. Intimately acquainted with town budgeting and operations, he knew where the skeletons were buried and was not shy about exhuming them.

Rocky Rockwood

In the days when heavy-equipment contractors scratched to make a year-round living, most small towns had a backhoe operator who catered to odd jobs and the occasional cesspool repair. In Foxboro, that was Irving "Rocky" Rockwood, who grew as weathered as his Mechanic Street barn. Spare and angular, he sang in the choir at Bethany Church, where each December he presided over "Rocky's Place," a vegetable stand at the church's annual Christmas Fair.

Billy Graham

It is a safe bet that no one confused Foxboro's Billy Graham with the well-known evangelist of the same name, probably because "our Billy" was much more interesting. A burly sergeant who doubled as the town's recreation director, he also was a practicing clinical hypnotist, a job that evolved from his police duties. "We can take a person back to the time of the accident or crime," Graham explained. "They usually tell us exactly what happened without the trauma of the original situation."

Herb Seltsam

A product of Foxboro schools, Herb Seltsam was a general contractor who founded both Foxboro-Mansfield Sand & Gravel and the Foxboro-Mansfield Coal & Oil Co. But during the 1960s and 1970s, he was cast as the disreputable owner of an unlicensed junkyard behind his Oak Street home. No small-town hoarder, Seltsam in younger days spent three years as stage assistant to "Hathaway the Magician." Later, as a member of the Civil Air Patrol, he operated a private airstrip on his property and, during World War II, used his own plane to scour the coastline for enemy subs. Alas, those exploits were forgotten by the 1980s when inspectors found drums of hazardous waste rotting amid the scrap. In time, the town seized the junkyard and carted off the scrap, a sad end for a nonconformist who delighted in defiance for so many years.

Joanna "JoJo" Levesque
Everyone knew Joanna "JoJo" Levesque had pipes, blowing away listeners with childhood renditions of R&B classics like "Mustang Sally." Attending Foxboro schools before pop celebrity intervened, Levesque gained recognition performing small gigs and community theater. A 1998 appearance on *Kids Say the Darndest Things* prompted offers from Oprah Winfrey, Rosie O'Donnell, and a feature role in the 2006 tween film *Aquamarine*. Musically, she released a self-titled debut album in 2004 and a second disc two years later.

Merle Caton
Making their home at "Caton's Corner," the intersection of Park and Comey Avenues, Merle and Ted Caton were literally and figuratively at the heart of community affairs. They made quite a team, particularly during the memorable minstrel shows sponsored by Legion Post 93. Merle's signature characters "Mother Nature" and "Gigi of Fiji Islands" remain theatrical legends, as was her later portrayal of Mrs. Claus at the annual Pub 99 employee Christmas party.

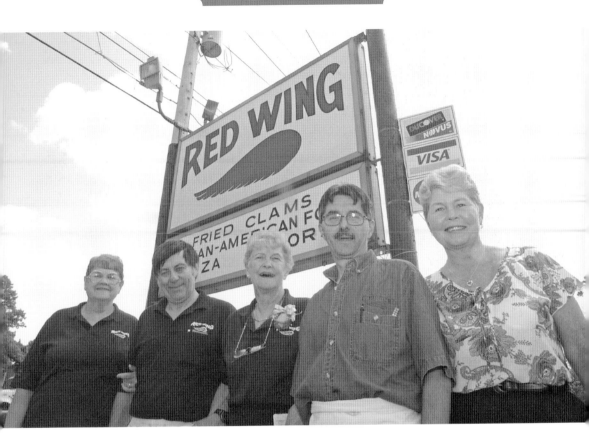

Jean Elliott

When Jean (Davison) Elliott started waitressing at the Red Wing Diner, Harry Truman was president, Studebakers were rolling off the assembly line, and *I Love Lucy* had just debuted on CBS. Elliott, who hung up her apron 52 years later, was one of five Davison sisters with lengthy track records at the Route 1 landmark renown for pizza and fried clams. They included Mary Burhart (48 years), Joan Seltsam (42 years), Christine Medeiros (40 years), and Judy Sloan (33 years). The Davison sisters were enshrined in restaurant folklore for one other reason: their grandmother Mary Hale owned and operated Hale's Diner, the legendary hole-in-the-wall located at Chestnut and North Streets. Elliott (center) is seen with her bosses and two sisters on her final day of work in 2003. From left to right are Mary Burhart, owners George and Oscar Campanario, and Judy Sloan.

Larry Jondro

Fate must have steered culinary school graduate Larry Jondro to a job managing Hanna's Restaurant in Foxboro, where he met his future wife, Alma, and displayed a knack for retail enterprise that characterized successful jobs in grocery and print-shop management as well as the "Big Yard Sale," held twice a year outside Jondro's Main Street home. Pictured at left with Rep. Kevin Poirier (center) and Sen. David Locke, Jondro also oversaw a commercial parking operation on Route 1 during stadium events for 34 years.

Red Sullivan

Having been a cook aboard submarines during the Korean War, Richard "Red" Sullivan never refused requests for his culinary talents—prepping dinners for American Legion Post 93 and breakfasts for men's groups at St. Mark's Church and the Foxboro senior center. Active in Legion affairs before his death in 2010, Sullivan was commander in both West Roxbury and Foxboro and held county- and state-level posts. He also served three terms as president of the Foxboro Historical Society, when he helped organize annual Founders Day dances.

Chet Harrington

In the hypersensitive world of youth sports, it is hard to imagine a less likely mentor, or more colorful personality, than Chet Harrington. Yet over four decades the wiry bantamweight in trademark Cubs cap has coached thousands of boys and is still revered by most of them. A Foxboro Youth Baseball fixture, Harrington maintained a knack for connecting with youngsters, probably because he is a kid himself. Not all players or parents responded favorably to the Harrington treatment; some could not get past the outsized persona, and others considered him obsessed with winning. But most loved him and especially his liberal doses of baseball strategy and sarcastic wisecracks. After throwing out a ceremonial first pitch to start the 2012 season, Harrington explained his philosophy. "I have three rules: First, learn the game. Second have fun. If you follow the first rule then do the second, it leads to the third rule—just win."

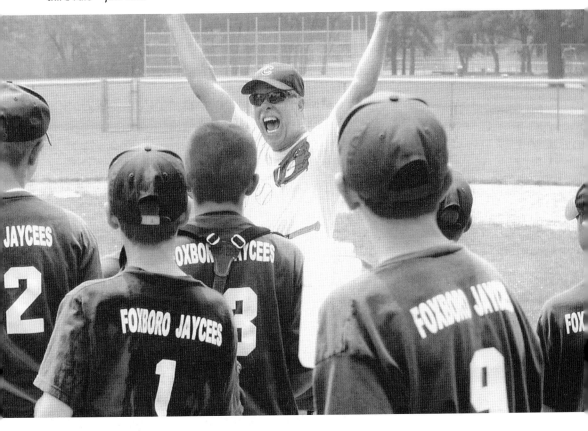

Norm Lawton

With one foot in Foxboro's agricultural past and another planted firmly in the present, Norm Lawton straddled one of the great transitional divides of postwar America. Raised on a chicken farm, he launched his own 4-H Poultry Club at age 16 and, later, earned a degree in animal husbandry from the Stockbridge School of Agriculture at the University of Massachusetts. In its heyday, Lawton's Farm on North Street shipped chicks to the far reaches of the globe, and Norm became an industry leader as president of the American Poultry and Hatchery Federation. A sharp businessman and keen observer of current events, he was entirely modern in his thinking and committed to the next generation as a 4-H leader. Lawton mentored thousands of youngsters over 63 years as a youth leader, program manager, and contest judge—a record that earned him induction into the National 4-H Hall of Fame in 2002. In later years, after Lawton's son and granddaughter has repositioned the family farm as a specialty supplier of raw milk, Lawton sometimes held court at the old North Street barn, seemingly transplanted into the present day from another, simpler era. Soft-spoken and given to folksy, homespun inflection, he was often portrayed by out-of-town media outlets as a backwoods New Englander holding out against progress, an image he delighted in cultivating, which provided a jarring contrast with his high-profile abutter, New England Patriots' owner Robert Kraft.

CHAPTER THREE

The Companies They Kept

Never a mill town in the strictest sense, Foxboro at various times has very much been a company town and, with waterpower widely available, an incubator for early manufacturing efforts. Even within the subtext of sustenance agriculture, a condition that endured for some into the 20th century, commercial enterprise consistently emerged at key moments based on the availability of capital, technology, and labor. Just as a rising tide lifts all boats, the town's economic evolution generally follows distinct eras, straw bonnet manufacturing in the mid- to late 1800s, instrumentation and process controls through much of the 1900s, and professional sports and entertainment at present.

From the beginning, many of Foxboro's preeminent citizens have left their mark and made their fortunes in the realm of commerce. Sawmills, grist mills, forges, and foundries were among the community's earliest business concerns, followed by dye houses, tanneries, and gunsmiths. Some were successful and others not, but all were launched in response to consumer demand for goods and services.

While some Foxboro business legends are more properly categorized as visionaries, the following gallery represents a range of sectors, including manufacturing, banking, insurance, and pharmaceuticals, while helping to personalize a number of broad economic currents, like the rise of a merchant class coupled with the growth of a wage-based economy, the emergence of the automobile as a defining feature of American life, and the postwar housing boom that ensured new construction would be the dominant economic engine for decades to come. These are their stories.

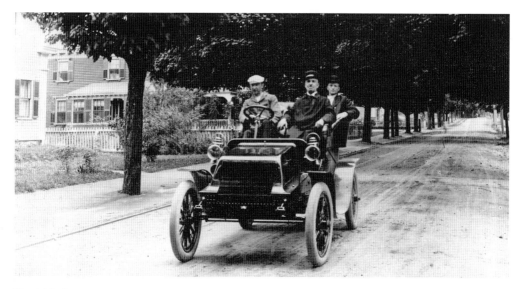

Bert Hedges

Tootling along a tree-lined Central Street in his merry Oldsmobile, Bert Hedges sits behind the wheel while his two passengers enjoy the ride. Hedges Brothers, located at 94 Central Street, began as a bicycle shop before becoming Foxboro's first auto dealership, selling and servicing horseless carriages to local citizens of means. It was not long before Hedges Brothers, its competitors, and successors usurped the local trolley service, forever changing the lives of ordinary townspeople.

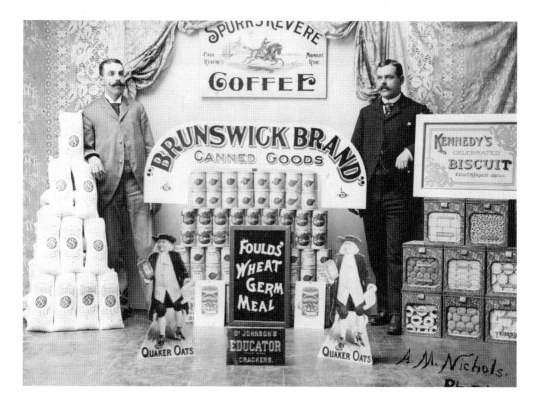

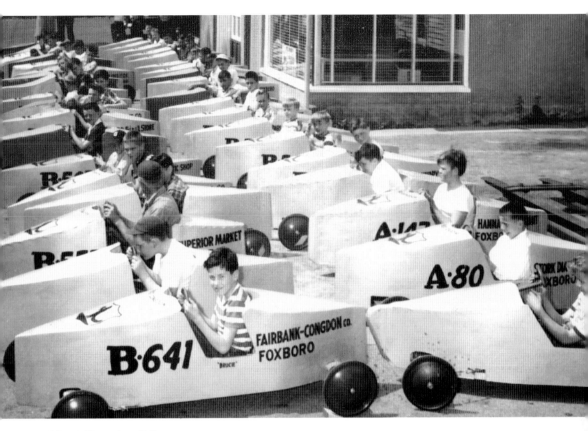

Newt Congdon & Sons

Congdon family members have been involved in the car business since 1928 when "Newt" Congdon and Dexter Fairbank opened Fairbank-Congdon Co. on Main Street. Franchised to sell Pontiacs and Oaklands (Oldsmobiles were added in 1931), it was six years before the partners were comfortable enough to take salaries. In those days, car dealers, like physicians, often conducted business by making house calls. "We certainly could not wait for them to come to our place," Congdon observed years later. After Fairbank died in 1951, the company regrouped as Congdon Pontiac Olds, moving to its present location facing the town Common in 1957. Upon Newt's retirement in 1975, sons Bruce and Dana came into the business as secretary-treasurer and president, respectively. The image is of a young "Brucie" Congdon in Car No. 641, prior to a soapbox derby competition; as noted on the tailfins, Fairbank-Congdon Co. sponsored the racer.

Wilber Brothers (OPPOSITE PAGE)

In the late 1800s, with a consumer-based society emerging, two enterprising brothers erected a building on Central Street to house a grocery store. Sumner and Frank Wilber soon offered canned meats and vegetables, coffee and tea, and a smattering of fresh produce—luxuries at a time when many families still stored vegetables in the root cellar for winter. Touting themselves as "the reliable cash grocers," the entrepreneurial Wilbers also had a firm grasp on the power of advertising. This photograph was taken for a complimentary calendar promoting the store.

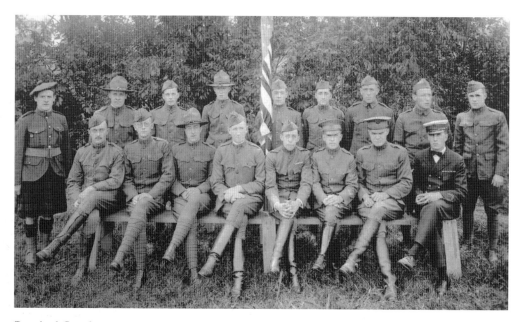

Percival Crocker

Shortly after entering World War I, the US military began training its first airmen. Included among them was Foxboro's Percival Crocker, who trained as a flight instructor. After the war, Crocker was the first commander of American Legion Post 93 and established a local business that endures to this day, the Sentry Company, which manufactures specialty furnaces for heat-tempering metals and alloys. Crocker piloted the firm for over 50 years as president and chairman of the board. In this photograph of returning World War I vets, he is seated fourth from right.

Alfred Ouimet

In this photograph, dated April 15, 1905, David Alfred Ouimet enjoys a cigar while outfitted in topcoat and bowler. He launched Ouimet's Pharmacy after acquiring a Central Street drugstore from Eli Phelps, who erected the three-story building around 1850. Eventually, sons Hilaire and Gill inherited the business. A third son, Victor, was a Navy pilot, who became the first local casualty of World War II when he failed to return from a sortie to the carrier *Wasp* in 1942.

Jackie O'Reilly

Of all the restoratives for happiness, it turns out that marriage was the best medicine for Jackie O'Reilly and her beloved Bill. The husband-and-wife pharmacists operated for three decades a Rexall drugstore at the corner of Central Street and the Common rotary. The familiar location, known to generations as "Bay State Corner," got its name from the original Bay State Drug, founded in 1898. The O'Reillys came to Foxboro by a circuitous route. Born in Lawrence in September 1925, Jacqueline Desprez returned with her parents to their native Belgium during the depths of the Depression. A decade later, the family returned aboard a refugee ship packed with Jews fleeing the Nazis, and because of a wartime shortage of pharmacists, Jackie was fast-tracked at the Massachusetts College of Pharmacy, graduating at age 19. At war's end, she met William O'Reilly, a B-17 waist gunner who had flown 33 missions over Europe, including a sortie on D-Day itself. They married, and he, too, became a pharmacist. In 1950, the young couple purchased the local drugstore, where old-fashioned cherry Cokes were soon mixed with the same care given to filling prescriptions. Jackie closed the business in 1983, a year after her husband died of a heart attack, but in many ways, her influence was just beginning. She became a trustee of the Boston Ballet and served as president of its fundraising arm, the Boston Ballet Society. With her passion for the arts, Jackie earned a statewide reputation for developing a funding source for the arts through the state lottery—and remains the one person most responsible for establishing arts councils in each of the Bay State's 351 cities and towns.

Frank Fitzpatrick
By the time Frank Fitzpatrick opened Pioneer Food Store on February 4, 1932, he already knew something about pricing, absorbing lessons at the Foxboro Cash Store before leaving to compete with his former employer. After the store closed in 1954, Fitzpatrick was hired as custodian and crossing guard at the old Robinson Hill School and then, in 1975, the Taylor School, where he worked 10 more years. While pursuing these two careers, Fitzpatrick remained active in the Foxboro Grange for over 70 years, even as Foxboro lost its rural character.

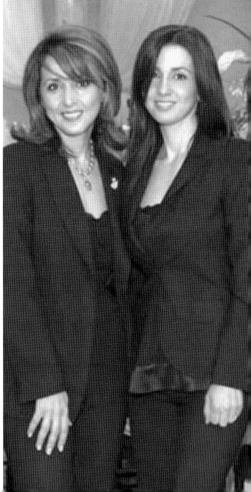

The Kourtidis Family
When Efstathios "Steve" and Kiparisia "Kathy" Kourtidis arrived in Boston from Greece in 1981, the first order of business was opening a Newbury Street restaurant. The second, seven years later, was acquiring the ramshackle Lakeview Ballroom, Foxboro's once-proud dance hall that had been limping along for decades. Overhauled and upgraded, renamed Lake View Pavilion and managed by daughters Natalia Kapourelakos (left) and Anastasia Tsoumbasnos (right), the facility has since become a magnet for upscale weddings and other formal events.

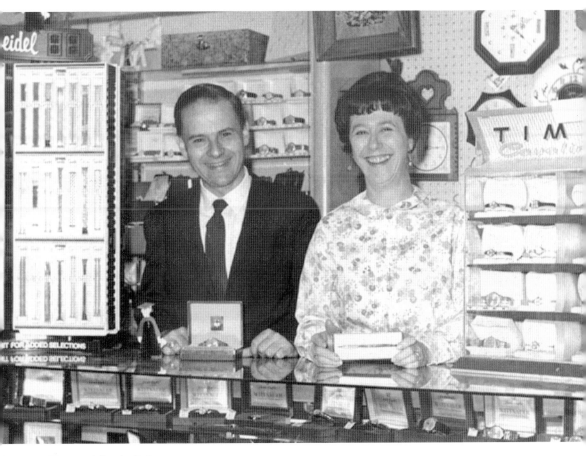

Alex and Sonja Spier

Their story is an almost mythic reflection of the American dream: immigrants flee Europe after World War II, settle in Foxboro, and establish a successful jewelry business before branching out into real estate, ultimately becoming the town's largest landlord and among its most generous benefactors. That is the road traveled by Alex and Sonja Spier, who succeeded by virtue of hard work and a near-obsessive attention to detail. The couple also has pursued a long-standing commitment to public service, with Alex in roles related to long-term planning and land development and Sonja on the Foxborough Council on Aging. But that is only part of the story. Working through the Spier Family Foundation, Alex and Sonja, aided by their two children and respective spouses, channeled much of their giving to Massachusetts General Hospital and the Foxboro YMCA, largely underwriting the construction of indoor and outdoor pools at the facility. In addition, Alex Spier's ongoing support for Habitat for Humanity led to his being recognized as one of ten Men of Distinction for 2013 in Naples, Florida, where he has spent winters for many years.

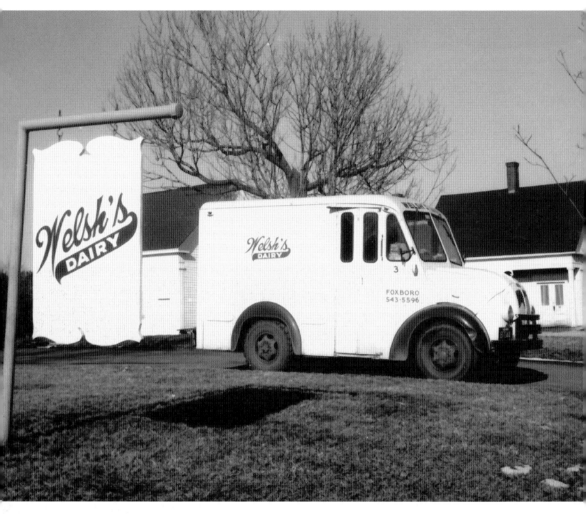

Welsh's Dairy

Back when milk boxes graced the back steps of local households, Welsh's Dairy was the cream of the crop, literally. Welsh's flagship product was its "Cream Crest" Grade A homogenized milk, which customers craved because it boasted higher butterfat content. Located at 205 South Street, on the upside of Foundry Pond, Welsh's was Foxboro's last remaining commercial dairy in 1973, when it sold its routes to Bliss Dairy and the familiar white trucks with green lettering vanished forever. Originally known as Pine Cone Farm, the business was owned by brothers Joseph and Thomas Welsh. Both were reared in the dairy business founded by their father in 1923 and took over upon his death in 1947. Almost immediately they made improvements, overhauling the processing plant and broadening the product line to include chocolate milk, butter, eggs, cheese, ice cream, and other items. More critically, the brothers phased out their dairy herd, processing raw milk purchased from outside suppliers while focusing on expanding their delivery routes—tripling business in seven years. But time marches on, and Welsh's eventually followed other small dairies, succumbing to competition from corporate farms and grocery and convenience store chains.

Russell McKenzie

By the time he died in 1952, Russell McKenzie's face was pretty well known in Foxboro. Son of a local blacksmith turned auto dealer, the 1914 Foxboro High graduate interrupted his studies at Brown University to serve in the Coast Guard during World War I. After the war, McKenzie became a charter member of American Legion Post 93 and, for the next 25 years, until superseded by a World War II veteran, served as officer of the day at the town's annual Memorial Day observances. Following his father's death in 1920, he also joined his brother Harold in what became known as McKenzie Motors at 100 Central Street. In the accompanying photograph, a GMAC sales representative (left) greets McKenzie at the old garage. The business thrived but somehow Russell found time to indulge in a variety of community roles. Appointed local postmaster in 1922 when the central post office was located on the other side of the common, he launched twice-daily home delivery in the center of town, a practice that continued until 1950. Giving up the postal job in 1929, he was elected town moderator each year for a quarter century and also served as president of Foxborough Savings Bank and as a trustee of Norwood Hospital. During World War II, McKenzie chaired the regional Selective Service Board (more commonly known as the Draft Board), which represented Foxboro, Norwood, and Sharon. While he was engaged in these duties, Harold McKenzie, a skilled photographer, was capturing many of the most enduring images of Foxboro from the era, including several in this book.

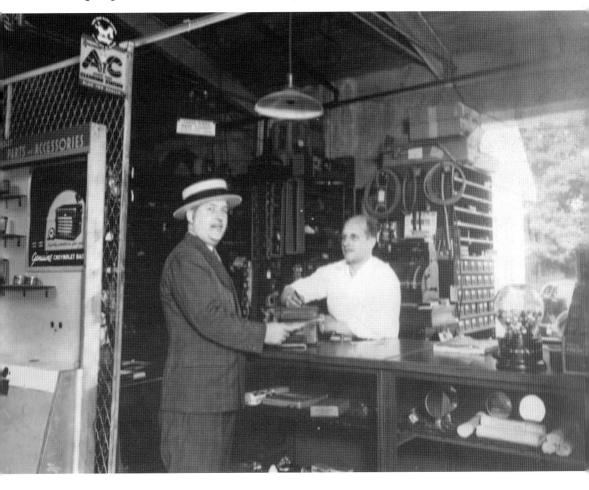

William Buckley Jr.

For the past quarter century, few individuals have had a greater impact on the face of Foxboro than William Buckley Jr. A 1981 West Point graduate, Buckley returned home from active duty and transitioned the family business, Bay Colony Group, from a surveying firm founded by his father to a full-service company providing land-planning, design, and engineering services. Since then, through boom-and-bust cycles, Bay Colony has delivered a creative vision for much of Foxboro's residential and commercial development, including the landmark state hospital reuse project. Buckley has been a builder in other ways as well, most notably as a trustee at the Foxborough Regional Charter School. Beginning when the school opened in September 1998, Buckley's engineering background helped steer this start-up school, serving 21 area communities, through a series of building upgrades and expansions, all culminating in 2012 in an $18-million facilities expansion that housed 27 new classrooms, a double gymnasium, a renovated cafeteria, media center, and new science labs. During this same period, Buckley was largely responsible for reviving two other programs providing opportunities for local students: an active Rotarian, he reinvigorated the local club's support for Rotary's foreign student exchange (personally hosting high schoolers from Germany and Venezuela); and as a member of American Legion Post 93, he worked with local school administrators to promote the Legion's Boys and Girls State mock government program, which, not incidentally, he attended as a Foxboro High School junior in 1976.

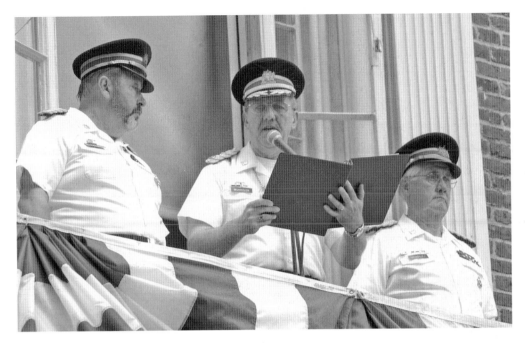

George Morrison

Tradition matters to George Morrison—and never more so than on July 4, 2003, when, as commander of the Ancient & Honorable Artillery Company of Massachusetts, he stepped onto Old State House balcony to deliver the ceremonial reading of the Declaration of Independence, kicking off Boston's Fourth of July festivities. An active Rotarian and lay leader at St. Mark's Church, Morrison moved to Foxboro in 1969 and, seven years later, founded his own construction management firm, Unique Services Construction, which specializes in designing, remodeling, and outfitting dental offices.

Dick Stevens

The youngest bank president in Massachusetts's history when he joined Foxborough Savings in 1975, 30-year-old Dick Stevens inherited a troubled institution, with directors alerted of a possible state takeover. Over the next 29 years, Stevens diversified the bank's traditional business, generated record profits, and put substance behind the sloganeering of "community banking" so prevalent in the industry. Arguably his most notable contribution, a public stock offering in the 1980s added considerably to the net worth of many local families and culminated in a remarkable $100-per-share buyout by Banknorth in November 2003.

59

Rocco Giovino

Helping raise five children in the days before disposables, Rocco "Rocky" Giovino understood the importance of clean diapers—knowledge he put to use as proprietor of Stork Diaper Service on Chestnut Street. The community-minded businessman also served on the town advisory committee, was Little League treasurer and Lions Club president, and chaired the annual Heart Fund drive. He was also a perennial candidate for public office, often seeking election to the board of selectmen. Earnest efforts notwithstanding, Giovino never found favor with voters and usually finished last on the ballot.

Grace Hutchins

In the years before box stores and suburban malls, Grace Hutchins was a local institution, particularly for generations of local youngsters on the hunt for penny candy. Spry and energetic, she operated the Foxboro 5¢ to $1 Store (better known as "Hutchins 5 & 10") on Central Street for four decades—first with her husband, Albert, who left the S.S. Kresge chain in 1940 to launch his own business, and then by herself following his death. She died in 1989 and is buried at Rock Hill Cemetery.

Bob Ferestein

Since following his father into farming, Bob Ferestein has stayed true to his roots, operating a retail store and farm supply outlet with his son David and wife, Ann. Ferestein still delivers hay to southeastern Massachusetts farms but the primary focus is the retail store, built in 1982, when the family still had 80 milking cows grazing out back. Business these days is brisk in December, when the Feresteins do a booming business in prime Christmas trees, wreaths, and other holiday items.

Janice Barrows

When Janice Barrows graduated Foxboro High School in 1946, few women had expectations of a career, much less owning a successful business. Yet before her death in April 2013, Barrows had done both. After raising three children, the longtime Mansfield resident in 1977 launched Barrows Insurance Agency out of her Pratt Street home. Assisted by sons Jay and Rob, Barrows expanded to a North Main Street location, where the agency has remained a Mansfield landmark for 40 years.

Dr. William Best

For 37 years, he was Foxboro's resident Dr. Doolittle, walking and even talking with animals arriving for treatment at the Mechanic Street veterinary practice acquired from Louis Polansky in 1976. It was a perfect marriage for Dr. William Best, who lived with his family in a home attached to the Foxboro Animal Clinic. Specializing in surgical procedures, Best sold the business to Dr. Richard Moschella in 1999 while remaining an associate and continuing to live on-site for another 14 years. He relocated to Cape Cod with his wife in 2013.

Mordini Brothers

A photograph hanging in the Mechanic Street offices of Mordini Brothers Construction depicts Joe (left) and Bob (right) Mordini with their father, Joseph Sr., an Italian immigrant who followed his dream to America. In the half century since building their first house in Foxboro, the family-owned firm constructed more than 175 dwellings from modest capes to million-dollar homes in sprawling neighborhoods. Although Bob Mordini died in 1995, the business continued with sons Steven and Mark. Now largely retired, Joe Mordini keeps busy as an accomplished woodworker, challenging himself with intricate furniture projects.

Lloyd Smith

Like many who came of age during World War II, Lloyd Smith wanted badly to enlist before the fighting ended but not badly enough for the baseball captain to miss his final high school game with rival Canton. So after recording the final out, Smith hastily doffed his uniform on route to Canton Junction, where he caught a train for the naval base at Sampson, New York. Best remembered as proprietor of several filling stations, Smith spent several years with Billy Graham's crusades, traveling and making stage appearances with the well-known evangelist. He returned home in 1954, and with his brother Francis, he opened Foxboro's first full-service garage, a Tydol station beside the Orpheum Theater. In 1969, he opened Smith's Mobil on Central Street, which was sold 18 years later. Smith died in 2003, but took pride in being the third generation of Smiths doing business in town. His paternal grandfather, George Smith, operated an icehouse on Cocasset Street, and his uncle Milton Smith ran a heating oil business. Both Milton (center) and Lloyd (left) are pictured outside the icehouse harvesting another cash crop.

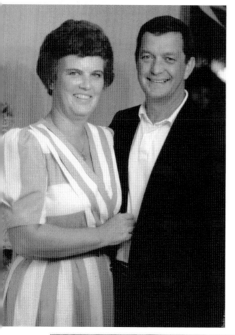

Pete Lovely

If people are truly judged by the company they keep, Pete Lovely's circle of friends must be wise indeed. A Marine Corps veteran, Lovely joined the real estate firm founded by his parents, Cleve and Marjorie, in 1961 and diversified into insurance the following year. Between work and family, Lovely also served as president of the Hockomock YMCA, director of the Foxboro Community Club, and chairman of the Foxboro Cancer Crusade. Nearing retirement, Pete and his wife, Ann, are preparing to hand off the reins to sons John and Jeff.

Richard Leggee

A bank president who puffed on a tuba in a Dixieland band while pursuing an interest in local history, Dick Leggee (at left in photograph) was president of Foxboro Federal Savings and Loan Association in 1968 when the state authorized Foxboro's first-ever historic commission. Jumping on board, Leggee was editor of a hardcover pictorial history published during the town's bicentennial in 1978 and also one of the earliest volunteers at Foxboro Cable Access. His other great passion was the tuba, which he played into his 80s with several jazz ensembles.

CHAPTER FOUR

Civic Duties

Thoreau's oft-repeated maxim "that government is best which governs least" is everybody's favorite when tax bills come due. But with so much of the shared narrative written by those hardy souls willing to shoulder the burden of conducting the public's business, it is inevitable that some of the community's most recognizable and beloved figures have made their mark through civic engagement and local government.

Unlike most citizens, who tend to take town affairs seriously only when a particular issue hits close to home, these notable figures have devoted more than just time and energy to this collective enterprise called local government—they have contributed a little bit of their hearts and souls as well. From mail delivery to police and fire protection, from education to environmental management, Foxboro's public servants, career employees, and volunteer officials make certain the streets are plowed, rubbish collected, and faucets kept running, meeting the everyday needs of homeowners, businesses, and the motoring public.

Of course, the scope of this mission has expanded over the years, with citizens asking government to play a more active, far-reaching role in the area's collective experience, and government responding to these rising expectations. This evolution has led to new regulatory and enforcement powers and greater oversight of activities once considered private. The 27 individuals profiled over the following pages have been part of that journey—all united by a common sense of duty, obligation, and purpose. That Foxboro remains a thriving, dynamic community is a testament to their influence. These are their stories.

Earle Sullivan

In 24 years as editor of the *Foxboro Reporter*, Earle Sullivan covered the news while remaining one of the town's top newsmakers. For 14 years, mostly between world wars, Sullivan was elected to consecutive one-year terms on the board of selectmen (11 as chairman) and was just as influential in local civic, social, and fraternal activities. A World War I veteran who served in France with the 20th US Army Corps of Engineers, Sullivan was a charter member of American Legion Post 93, master of Foxboro Grange, and president of Foxboro Lions. During World War II, he served as consultant to the Selective Service Board, regional publicity director for all war bond drives, and publicity manager for local United Service Organizations (USO) campaigns. But the biggest job was yet to come for Sullivan, who, in 1947, was named director of community relations at Los Alamos, New Mexico, the desert community at ground zero for the Manhattan Project as well as a nascent postwar nuclear industry. Sullivan's years at Los Alamos were busy and tragically short. He was stricken in January 1951 at age 54, leaving a young wife and daughter. The athletic stadium at Los Alamos High School is named Sullivan Field in his honor.

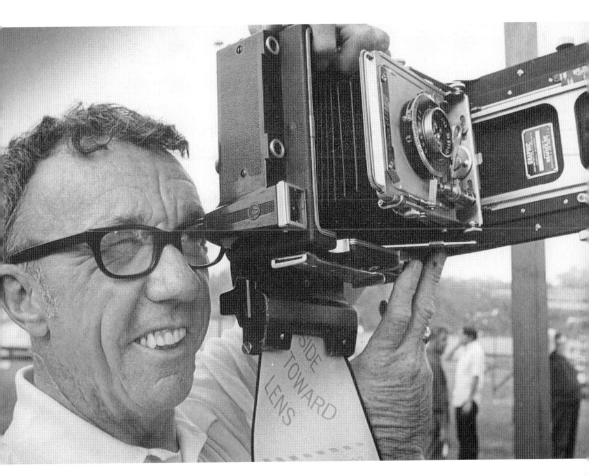

Vin Igo

As a newsman, community liaison for the Foxboro Company, and public official serving concurrently in multiple positions for a cumulative 179 years, Vin Igo wore his heart on his sleeve. Yet for all his myriad contributions—47 years on the school committee, a half century as bail commissioner, 20 years as a high school and collegiate basketball referee, a life member of the Foxboro Lions Club and Knights of Columbus—Vin still had ink in his veins. A high schooler when first asked to cover Foxboro news and sports for the old *Attleboro Sun*, he was hired at the Foxboro Company after a brief stint in the Coast Guard during World War II. As fate would have it, Earle Sullivan, editor of the *Foxboro Reporter* (then owned by the Foxboro Company), was retiring and management determined the paper could no longer be a one-man operation. So, Vin signed on, making an immediate impact with news and sports photographs and, on April 7, 1948, his weekly sports column "Going Along with Igo." That column became a lifetime commitment, published each Thursday until just before his death in 2006, making it one of the nation's longest-running newspaper features.

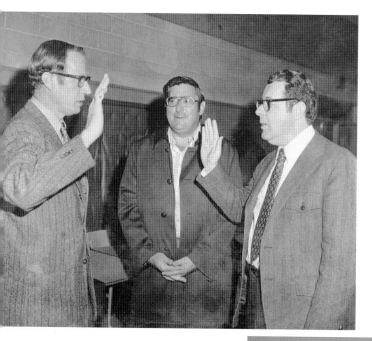

Ed Fox

In the 30 years since Ed Fox left town for a new job in Connecticut, time has done nothing to diminish his reputation as a forward-thinking leader. Arriving in 1955 after being discharged by the Navy, Fox served in several elected and appointed posts. Yet his real contributions came later, during three terms as a selectman. Pictured on the left being sworn in by moderator Garrett Spillane (with colleague Jerry Rodman looking on), Fox was instrumental in negotiating Foxboro's first cable television contract while helping the community adjust to a new reality as America's smallest town to host a professional sports complex.

Leo Norton

Leo Norton was a banker by trade and a Rotarian by choice. But the March of Dimes' mission to prevent birth defects remained closest to his heart. A Milton native, Norton moved to Foxboro in 1972, and in no time, he chaired the Industrial Development Commission, was elected to the board of selectmen, and became the first president of Foxboro Rotary. His 30-year association with March of Dimes culminated in 1978 when Norton became the first Massachusetts resident named Man of the Year by the national foundation. His early death at 44 shocked the community.

Bill Hocking

Few responded to the call of the wild like Bill Hocking, a naturalist, aspiring geologist, mushroom enthusiast, and kindly mentor to those hoping to experience the wilderness just beyond their own backyards. A bulwark on the town conservation commission for 26 years, he was a principled environmentalist without being obstructionist. Hocking was happiest at Borderland State Park in Easton, where he served the advisory council from 1972 to 2008 and led nature and geology walks. A year after his death at 76, a Main Street walking trail was renamed the William O. Hocking Trail in his honor.

Hazel Bourne

Hazel Bourne's Pleasant Street backyard was like stepping into the Garden of Eden. Framed by lush shrubs, flowering trees, and ornamentals, the picturesque landscape featured a fern garden she had grown from spores. President of both the state Garden Club Federation and New England Wildflower Society, Bourne cofounded the Foxboro Garden Club and was recruited for the town's first-ever conservation commission. Yet Bourne displayed backbone to complement her green thumb; during World War II, she enlisted in the Women's Army Corps, leaving husband and daughter in Foxboro while assigned a duty post in Washington, DC.

69

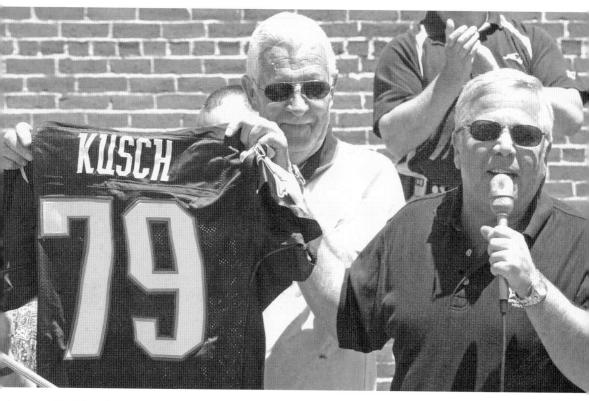

Carl Kusch

Some people are talkers by nature. Still others are dreamers. Carl Kusch, a decorated World War II submariner who settled in Foxboro, was a doer. During the half century before his death in 2010, his center of gravity exerted an irresistible pull on the programs, institutions, and aspirations that defined community life. Kusch wore many hats, all comfortably: local postmaster and longtime veteran's agent; past commander of American Legion Post 93 and 30-year chairman of the historical commission; and key player on the 1978 Foxborough Bicentennial Committee and its successor, the Founders Day planning committee. He was instrumental in relocating the one-room Paine Schoolhouse behind town hall as a living museum. He also had a low tolerance for grandstanding or personal agendas and was perfectly willing to puncture hyperinflated egos, especially those on the town payroll. But arguably Kusch's most poignant, and important, role involved a somber springtime ritual. Each year, at the town's Memorial Day observances, Kusch, as master of ceremonies, would solemnly recite the "Roll Call of the Dead," a list of local veterans who died over the past 12 months and the conflict in which they served. Followed by haunting notes of *Taps* and a rifle salute, this eloquent litany remained the emotional focus of Foxboro's small-town ceremonies—one he approached with a prideful mix of resolve and resignation.

Doug Smith

In 39 years as a postal carrier, Doug Smith figured he drove a million or so miles over local roadways and never had an accident. A Navy veteran, Smith was on hand for two pivotal moments in history. He was aboard the USS *Saratoga* on blockade duty during the Cuban Missile Crisis in 1962 and was on the USS *Ticonderoga* in the Gulf of Tonkin during the 1964 incident that escalated America's role in Vietnam. Smith later became the first Vietnam-era vet to command VFW Post 2626.

Russell Wheeler

Russell Wheeler, who served in World War I, remained active at Lawrence W. Foster Post 93 American Legion the rest of his life. Shown at a Memorial Day program shortly before his death, Wheeler was a postal worker who bore the distinction of holding Badge No. 1 as Foxboro's very first letter carrier, issued when the local post office launched home delivery (twice daily in the center of town).

71

Garrett Spillane

Garrett Spillane was a local legend long before his death from cancer in February 2002. A 1951 Foxboro High School graduate who became the town's preeminent land-use attorney, he also was the longest-serving moderator in Foxboro history and, when elected, the youngest member of the state legislature. Fresh from Boston College Law School, Spillane hung out his shingle and, barely a year later, challenged incumbent moderator Ellis Brown. Well-established and respected, Brown was seen as a shoo-in, but the upstart prevailed, and just seven days later, Spillane presided over his first town meeting. A year later, at age 27, he threw his hat into the ring for a legislative seat—again a prohibitive underdog—running as a Democrat in a five-town district where Republicans held a 2-1 voter advantage. When the dust settled, he had eked out an improbable 243-vote victory. But for all his varied roles, Spillane's ample gifts were on fullest display at town meetings. It truly was his stage and he played it like a virtuoso, usually conducting townspeople to a harmonious resolution of matters at hand. He had perfect pitch, serving up just the right dose of gravitas or levity, as befitting the occasion. He also was unfailingly courteous, a gentleman who maintained unflinching respect, both for the forum and for those who took the time to make the town's business their own.

Marie Crimmins

The longest-serving clerk since Foxboro's incorporation in 1778, Marie Crimmins's warm smile and sweet disposition were for many the face of town government. Constantly interacting with the public, she was a keen student of local affairs and kept a finger firmly on the town's pulse before retiring in 2008. Crimmins was also a trusted confidant to town hall observers, whose spot-on election postmortems were worth missing breakfast for, and waged a career-long campaign against removing Foxboro's "UGH" suffix on official correspondence.

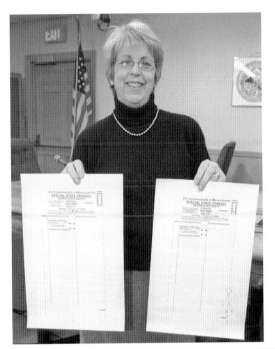

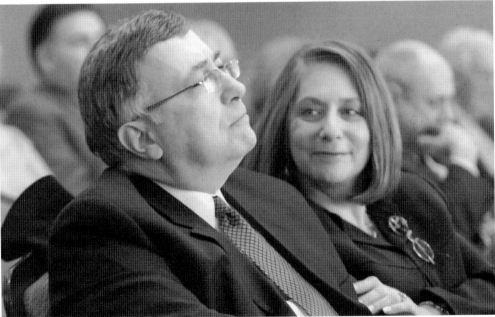

Andrew Gala

The week before selectmen hired Andrew Gala as town administrator, J.R. Ewing was famously shot on the prime-time soap *Dallas* and gasoline cost $1.19 a gallon. A car enthusiast who owned a 1961 Corvette, the even-tempered Milford resident oversaw Foxboro's municipal affairs for three decades, showing considerable skill running a small town with a NFL stadium and a harness track. His peers thought so too; at a 2010 retirement party, Gala and his wife, Susan, listened proudly while colleagues described him as a perfect gentleman, a man of integrity.

Bill Gaffey

A doyen of downtown Foxboro until his death in 2001, Korean War veteran Bill Gaffey may have been the lone barber elected to the board of selectmen. During a particularly tumultuous period, Gaffey was modest, affable, and unfailingly gracious, never craving the spotlight or seeking credit for the board's accomplishments. And after completing three years in a position where personal enmity more or less goes with the territory, Gaffey walked away with a clear conscience and an even wider circle of friends than he had going in.

Harriet and Harold Blomberg

Were spousal privileges invoked for public service, Harriet and Harold Blomberg would be worthy recipients, having each done their time in office. A World War II Navy veteran, he migrated between the planning board, board of health, and conservation commission for 25 years. She was an elementary teacher and church organist who enshrined two innovations during her lone term as selectman: earmarking an autumn town meeting specifically for zoning or land-use proposals and designating time at each selectmen's meeting—dubbed "Citizen's Input"—for ordinary folks to air their gripes.

ATTY. & MRS.
ELLIS F. BROWN

Ellis Brown

The day Foxboro's Ellis Brown was sworn as presiding justice at Wrentham District Court, roads leading to the courthouse were illuminated with red flares a mile in both directions—a token symbol of respect from the law enforcement community. A World War II veteran and practicing attorney, Brown was elected town moderator from 1952 to 1958, named a special justice for noncriminal matters in 1967, and then elevated to the full bench five years later. Retiring to his Main Street farm with wife, Muriel, Judge Brown died in 2007 and is buried at Rock Hill Cemetery.

N. Carl Annon

When N. Carl Annon was elected to the board of selectmen in 1951, the police department had a single cruiser at its disposal; when he stepped down 23 years later, Foxboro hosted an NFL franchise. Credited with a steadying influence during a period of unparalleled growth and change, Annon was honored by townspeople who proclaimed June 15, 1974, as "Carl Annon Day." The tribute included a testimonial dinner at the old Stadium Club at Schaefer Stadium, during which he was presented with a shiny new Ford Thunderbird, sporting "ANNON" vanity plates.

Barbara Hyland

For a time, she was the local fountainhead of a Republican resurgence, which trailed the election of Gov. William Weld in 1991. But Barbara Hyland was no ideologue; her activism started at the grassroots. Having cut her teeth on the Taylor School Parent Teacher Organization and three terms on the local school committee, Hyland was already active in Republican politics when state Rep. William Vernon resigned to take a political job. At the time, the 1st Bristol District included the entire town of Mansfield and parts of Foxboro, Norton, and Stoughton, giving candidates from Mansfield a huge advantage. Undaunted, Hyland threw her hat into the ring. A relentless campaigner, she squeaked by Easton Democrat Richard Driscoll in an April special election by 42 votes and then rolled over Driscoll by nearly 1,500 votes in a general election the following November. Two years later, she cemented her hold on the seat by convincingly beating back a challenge from up-and-coming Democrat John Manning of Foxboro. Hyland's election and subsequent retention of the 1st Bristol District seat literally altered the political landscape, and her influence with Weld helped ensure that all of Foxboro was included when district lines were redrawn in 1994. Hyland and her merry political band were also at the ground floor in jump-starting Foxboro's First Night celebration in 1993; this photograph is from First Night 1994. Life was good, but fate intervened. Hyland was diagnosed with cancer in 1998, and she relinquished her legislative seat in 2001 after five terms to focus on her illness. She died in November 2008 at age 64 and was buried at St. Mary's Cemetery adjacent to her close friend and political ally, Michael Coppola, who succeeded her in office.

Michael Coppola

The late Mike Coppola endeared himself to political supporters with a campaign slogan that was effective precisely because it happened to be true: "I Like Mike!" Elected to the state legislature as a Republican in 2001 to succeed Rep. Barbara Hyland, a dear friend and political ally diagnosed with cancer, Coppola was liked even by those who did not vote for him. A former barber turned entrepreneur who left the private sector and built a legacy of public service spanning 25 years, Coppola was Foxboro's preeminent elected official during the 1980s and 1990s. Moving to Foxboro with his wife, Ginny, in 1970, the Roslindale native immediately made his presence felt. Beginning in 1980, he served 9 years on the town planning board and then 12 more on the board of selectmen; for better or worse, Coppola came to personify town government for much of that period—so broad and ubiquitous was his involvement in civic affairs. But if voters respected his commitment to the town, they also were attracted by his decency, personal loyalty, and his most endearing quality, a willingness to poke fun at himself. Outside of politics, Coppola's interests remained numerous and varied. As a teenager, he built and raced cars, played guitar in a wedding band, and worked in his father's West Roxbury barbershop for 11 years before launching a business with his brother Larry. Founded in 1971, NEMPCO, Inc., was a motorcycle parts wholesale/distribution company the brothers moved to Route 1 in Foxboro in 1976. In a tragic turn, Coppola's legislative career was also cut short by a cancer diagnosis. After his death at age 62 in August 2005, Ginny Coppola won a special election to serve out the remainder of her husband's unexpired term.

Timothy O'Leary
In charge of the Foxboro state police barracks, Tim O'Leary was a soft-spoken Walnut Street resident who rose from the rank of trooper to staff sergeant in 18 months. No relation to Foxboro police chief Edward O'Leary, he moved to Foxboro in 1968 when Foxboro troopers covered the state's largest geographic territory. Even as an administrator, O'Leary never forgot the dangers of the job; in 1975, he was out of work for nine months after being struck by a drunk driver while assisting a disabled motorist on Route 128.

Dan McCarthy
Sometimes it takes a hard man to make a soft serve. A 1934 Foxboro High graduate who later became hometown police chief, Daniel McCarthy was noted for an unusual side job: he owned and operated the Dairy Queen on Main Street along with his wife and three daughters. McCarthy joined Foxboro police just before World War II, left for submarine duty, then returned, and eventually, succeeded Chief Dennis Dolan in 1976. A Little League coach for years, he attended the FBI Academy and is credited with modernizing the department.

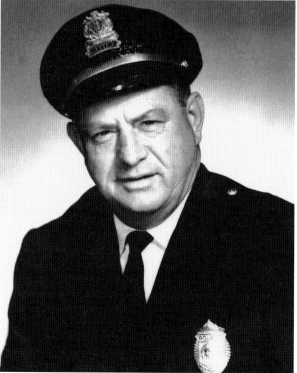

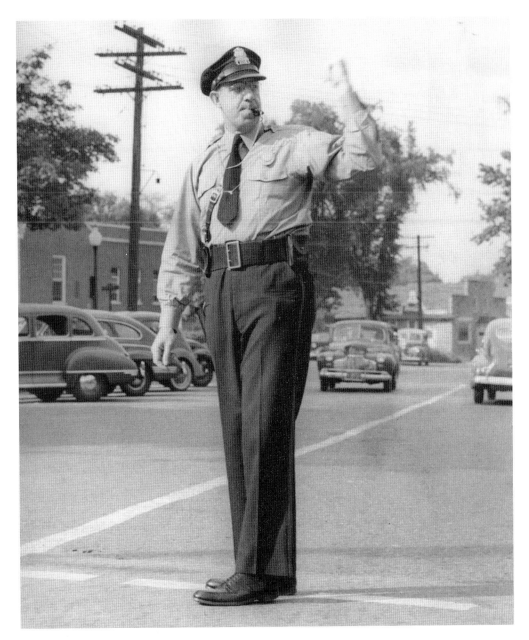

George Brown

A longtime auxiliary police officer and school crossing guard, George Brown was serenaded by 300 friends and acquaintances offering dozens of heartfelt tributes during a retirement party in March 1980. But none captured the essence of this gentle soul quite like the painting of him in uniform in front of the Lewis Elementary School titled, "The Teacher Wears a Uniform." Brown, who helped organize the first Foxboro Company security guard force, later oversaw the town's auxiliary police force, coordinating Sunday morning church details and even installing a sound system at Foxboro State Hospital so patients could enjoy dances. But he is remembered most fondly as a crossing guard, a kindly, reassuring presence in the lives of countless schoolchildren. "I loved the little kids," Brown remarked at his 1980 testimonial. "I would tie their shoes or help fix their bike—that helped teach them to respect the police."

Robert Lucas

Foxboro's longest-serving firefighter when he retired in 2004, Bob Lucas was still in high school in 1958 when appointed a junior call fireman. The fourth of five generations in the fire service, Lucas worked for seven chiefs and watched the job evolve from fire suppression to emergency medical response. A man of few words and strong opinions, he elicited both in 2009, flying an inverted American flag outside his South Street home to protest the country's malaise. The protest ended six weeks later when Massachusetts voters elected Republican Scott Brown to the US Senate.

Harold Clark

What distinguished Harold Clark from fire chiefs before and since were his obligations outside firefighting. Having joined the local fire company in 1927, Clark was named chief in 1944 and was instrumental in professionalizing a largely volunteer enterprise. Yet he also served 33 years as town tree warden, 22 years as moth superintendent (a critical post during infestations), and was named to the first conservation commission in 1962. After retiring, he served on the first historical commission, spearheading efforts to erect a building behind Memorial Hall to showcase the old horse-drawn fire steamer.

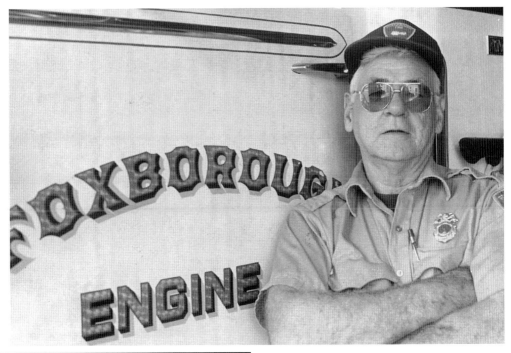

Jim Marshall

Foxboro Fire Department never adopted a
Roman collar as part of its dress uniform, but
Jim Marshall considered his job a higher calling
just the same. A Chicopee native who settled in
Foxboro after the war, he serviced oil burners
before joining the department in 1963. By the
time he retired in 1990, Marshall served as
private, lieutenant, deputy chief, and acting chief
and was so devoted to the extended fire service
family that his Walnut Street home became an
unofficial substation for off-duty colleagues. He
died in 2011 and is buried at Rock Hill Cemetery.

Jimmy Robertson

"Men of few words are the best men," read the
inscription beneath Jim Robertson's photograph
in the 1940 Foxboro High yearbook. A master
of stealth who usually escaped recognition
for good deeds, Robertson was a World War
II Army veteran and worked 39 years at the
Foxboro Company but was better known for
28 years as a call firefighter, the last 10 of which
as deputy chief. In this role, he kept books for
the 24-Club's monthly drawings with proceeds
available for community projects. A lifelong
bachelor, Robertson remained at home on
Lakeview Road caring for his aging parents.

Pete Turner

Whitmore "Pete" Turner sure kept himself busy. A Marine who served in the Pacific during World War II, he returned to start a contracting business and, in 1960, was named Foxboro's first building inspector, just in time for a real estate boom that saw over 800 homes built in the next decade. He also was the town's point man during construction of the original bargain basement Schaefer Stadium, served as an assessor, and was a trustee at Doolittle Home for 47 years. He is seen at right accepting an award from colleague William Buckley.

Bill Perry

Even among the unsung, he was unsung. Yet Bill Perry, who worked 42 years for the town highway department, was always "Mr. Dependable" when it counted. Pictured at a retirement dinner with wife, Marcia, and then-boss Robert Swanson, Perry remembered the pre–sidewalk plow era when laborers manually shoveled downtown sidewalks. But for sheer drama, nothing beat finding a South Street home burning with highway colleague Fred Curry. Racing inside, Perry and Curry found and pushed a woman through a first-floor window before firefighters arrived. Their reward? A day off without pay, courtesy of the board of selectmen.

CHAPTER FIVE

The Teachers and Preachers

Even before the town was formally incorporated in 1778, those living here took steps to provide youngsters a formal education. These pre-incorporation families—officially residents of Wrentham, Walpole, Stoughton, and Stoughtonham (now Sharon)—sent their children to district schools located at the outer reaches of the respective communities. One of these was built on Chestnut Street, opposite Kersey Road, in 1770. Another was located on Mechanic Street and yet another at Robbins Corner in present East Foxboro. Once incorporated in 1778, Foxboro took over the district schools and immediately began planning a decentralized, neighborhood model that endured well into the 20th century.

By the mid-1800s Foxboro was served by seven school districts, with the Everett, Quaker Hill, Paine, Pratt, Center, Plympton, and Cary schools educating primary students from their respective areas. Secondary education took longer. Foxboro did not have a high school for the first 87 years of its existence, and upon opening, it took another 11 years before anyone actually graduated. Yet then, as now, public schools were a community-wide imperative uniting citizens with a sense of common purpose and duty.

Of course, more critical than infrastructure or buildings have been the contributions from countless educators over the years, who created a supportive, nurturing environment and helped local schoolchildren spread their wings and unlock their inner potential. But not all of life's lessons are connected to the classroom. Villages really do raise children, and villagers have a role in that. So, it is only fitting that Foxboro's teaching legends include administrators, coaches, pastors, Scout leaders, and other authority figures who cared enough to guide, inspire, and mentor generations of young people. These are their stories.

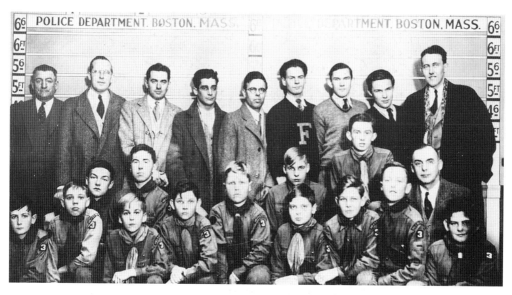

David Bragg

Living virtually next door to the fire station, David Bragg was well situated for his part-time job as call firefighter. This proximity endeared Bragg to adventure-seeking boys drawn to his house whenever an alarm sounded, hoping for a ride to the blaze in his 1937 Ford coupe. Bragg called the car "Esmeralda" and kept four pump cans strapped to the rear quarter. A lifelong bachelor, he was tremendously influential as a Boy Scout leader. This 1935 photograph shows Bragg, at center rear in glasses, accompanying a group of Scouts on a trip to the Boston Police Department.

Mike Johns

Since leaving the Navy on a disability, Mike Johns continued to model the personal values of integrity, duty, and honor—both as Foxboro's veterans' agent and through a long association with Boy Scouting. A 1982 Foxboro High graduate who earned a degree at Norwich University, Johns was a Navy helicopter pilot from 1986 to 1998, serving in Operation Desert Storm and other Persian Gulf deployments. But Johns, shown with wife, Janis, and two of three sons, contributed just as much as longtime Scoutmaster of Troop No. 7, providing a role model for hundreds of boys, and inspiring many to Eagle rank.

Stephen Massey

Only months after his first drum lesson in seventh-grade, Steve Massey knew he wanted to be a music teacher. And now, a half century later, he still marches to the beat of a different drummer, an educator more comfortable with his students than his colleagues. Since arriving in Foxboro schools as music department chair in 1980, Massey has been single-minded about developing a culture of high expectations in his music program. Whether conducting the annual Pops concert in black formal wear or instructing the Marching Band in a T-shirt and shorts, a singular mission to bring out the best in his students has defined Massey's career. He has done it by paring away distractions and demanding both focus and commitment and inasmuch has exerted an influence that reverberates, not just in the corridors at Foxboro High School, but through the community at large. Roughly 30 percent of Foxboro High students participate in music classes, many in the top-notch bands perpetually replenished by talented youngsters exposed to quality instruction at the elementary level. As a teacher, he personally directs the Foxboro High School concert band, marching band, wind Ensemble, jazz ensemble, jazz lab band, and two jazz choirs, as well as several academic courses. These units have been recognized consistently at the local, state, and national levels; indeed, the litany of accomplishments by Foxboro musicians is so lengthy as to be almost superfluous. His signature unit, the Foxboro High School jazz ensemble, has become a fixture each spring at the Essentially Ellington Jazz Competition at Lincoln Center. Since competing at Ellington for the first time in 1997 (and winning first prize), Foxboro musicians have qualified for the finals 11 times, which is more than any high school in the country. But Massey's program has never been exclusively about music; an Army veteran, he remains virtually alone among high school teachers in providing leadership training to students, arming them with practical techniques to motivate and inspire. Perhaps most gratifying for a veteran educator nearing the end of his career, Massey's legacy remains secure; his former students continue to spread a musical gospel to other communities. And the encore continues.

Natalie McComb

"Coachie" to her players, Natalie McComb excelled at basketball and softball in college, but her first love was field hockey, and that remains her legacy at Foxboro High. After a winless first season, McComb's teams amassed a 245-88-66 record over 32 years. Defined by a powerhouse 1975 squad, which posted 16 shutouts, they claimed 12 Hockomock titles and numerous tourney appearances. In her first year at Foxboro, McComb coached varsity and junior varsity field hockey, varsity and junior varsity basketball, and varsity softball—all for a $300 stipend. Later, she coached tennis as well.

Robert Girardin

Teaching or running, Robert Girardin had endurance. Hired at Foxboro High School in 1941, he retired as assistant principal in 1977 but then substituted for 17 more years while simultaneously serving 39 years on the board at Southeastern Regional Vocational School. Girardin attended Keene, New Hampshire, Normal School, where he boarded with one of his teachers, Clarence DeMar, a seven-time Boston Marathon winner. The two began training together, which is how Girardin entered the 1934 marathon. Competing in Keds, he finished 49th and continued to jog three miles daily until age 80, when he cut back to a brisk walk

Ruston Lodi

"His name is Mr. Lodi, he's made of macaroni." For 30 years, elementary students delighted in this ditty, passed down by youngsters who believed they possessed a well-kept secret. Because none ever dared repeat it in his presence, of course, they could not fathom that Ruston "Rusty" Lodi knew the rhyme before they were even born—and was delighted at the familiarity it implied. The first and only principal at the Robinson Hill School, Lodi died of cancer, at age 63, within months of his 1985 retirement, leaving a wife and five children.

Kaye Naylor

Kaye Naylor worked long enough that her successor, as Taylor School principal, was a former student. Hired in 1965 at the Robinson Hill School, she soon found all seven first-graders held back the previous year enrolled in her class. Naylor challenged convention by replacing traditional rows and grouping 32 desks in four clusters surrounding a rug where youngsters could sit and read. Appointed principal at Taylor School in 1996, she sought to connect with students by penning a personal note on all 350 report cards.

Al Stewart

There is a reason Al Stewart is remembered at Foxboro High School with a Spirit Award given in his memory each year. In more than three decades as a math teacher, coach, and athletic director, Stewart was the official flag waver, unofficial booster in chief, and all-around tub-thumper for the Blue & Gold. Arriving in Foxboro in 1952 from Franklin Academy in New York State, where he coached football and track and taught seven periods a day, the Revere native was hired to teach mathematics and, most importantly, succeed the legendary John Certuse as football coach (he also coached the track team). Politely rebuffing suggestions from principal Winfield Potter that he continue the single-wing formation favored by Certuse, Stewart installed the Wing T and rumbled to 23 straight wins in his first three seasons. Hockomock League rivals who had been heartened by Certuse's departure now rued the prospect of having to face Stewart's bruising line-ups. His players reflected his personality and took pride in their toughness—a quality on full display in Stewart's last game as coach, the 1961 Thanksgiving Day classic against Mansfield. At 5-3, Foxboro faced a dominant Mansfield squad led by the explosive Ron Gentili, who ran roughshod over the rest of the league. Sixty minutes later, Gentili had been held to 44 yards rushing as the Warriors gift-wrapped an improbable 12-6 victory for their beloved coach. Yet as spirited as he was on the sidelines, Stewart raised his rah-rah game to new heights after taking over as athletic director. For years, he was the prelate of Foxboro High School pep rallies, orchestrating mounting crescendos of noise, whipping the student body into a frenzy, and loving every minute of it.

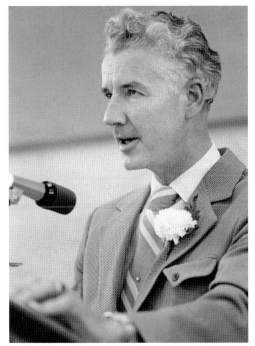

John Ahern

Though slight of stature, John Ahern's shadow still looms in his hometown. A lifelong bachelor who died in 2005, he was president of the class of 1940 before getting sidetracked by World War II and serving as radioman and gunner aboard a B-17, flying 30 combat missions over Europe. Though he seriously considered a mid-life calling to the priesthood, Ahern was perfectly cast as principal of Foxboro High School, bringing a moral and intellectual weight to the job that still resonates. When he retired early at 50, a grateful community renamed its junior high school in his honor.

Bea Smith and Carolyn Michelmore

Both teachers themselves, Bea Smith and Caroline Michelmore understood the key to academic success often started with self-confidence. They put this principle into action in 1976, organizing Each One Reach One, a mentorship program pairing community volunteers with students needing adult guidance and direction. The organizers, seated at a reception with some of the adult volunteers, were well suited to the task. Smith taught for $850 a year at the Paine School on Spring Street while Michelmore, a junior high civics teacher, was always gratified years later whenever her students emerged as community leaders.

Rev. William Barton
Nearly a century after his death, Rev. William Barton remains one of America's foremost Lincoln scholars and author of six volumes on the 16th president. Pictured with wife, Esther, at their summer home next to Sunset Lake on Granite Street, Barton also wrote extensively on religious matters. A prominent clergyman, he had been a circuit rider in Tennessee before coming to the Shawmut Congregational Church in Boston, then to a church in Oak Park, Illinois. Barton retired permanently to Foxboro in 1925 and bequeathed the homestead and surrounding woodland for use as a state park.

Rev. Stephen Madden
When local parishioners learned Rev. Stephen Madden was returning to St. Mary's Church after an eight-year hiatus, they burst into applause. Parochial vicar at St. Mary's from 1993 to 2000, Madden was reassigned to churches in Needham and Watertown before returning as pastor in April 2008. Throughout his years in Foxboro, "Father Steve" has provided steady leadership through periods of upheaval in American Catholicism and affirmed the church's central role in the lives of local families. Seen greeting parishioners following a mass to mark the 25th anniversary of his ordination, Madden's enduring grace here has been amazing indeed.

Dr. Frank Boyden

Infatuated with horses when he graduated Foxboro High School at the young age of 16, Frank Boyden's greatest ambition was to work at the local livery stable. It did not quite work out that way. Instead of horses, Boyden spent 66 years as headmaster at Deerfield Academy, ultimately becoming one of America's most distinguished educators. Born on September 16, 1879, in the family home on South Street, he eventually received 23 honorary degrees, many of them doctorates, and served on the boards of 26 institutions, including as trustee president at the University of Massachusetts. When Boyden arrived in 1902, Deerfield enrolled just 14 students. When he retired in 1968, it was one of the leading prep schools in America, on a level with Andover and Exeter. Immortalized in John McPhee's 1965 book *The Headmaster*, Boyden earned a variety of nicknames over the years but was perhaps best known by the sobriquet "the Head," usually employed with just a touch of awe. He had a simple guideline for administering a good school, keep the students busy, which explains his focus on athletics. Throughout his years at Deerfield, Boyden remained connected to the football, basketball, and baseball teams. He would sit on the bench, usually beside the actual coach, with an uncanny knack of knowing just when to make a substitution, send in a particular player, or call for a double steal. Born to a family of ministers and missionaries, he was never overtly religious but lived by Christian principles. His son John Boyden said that he never drank, smoked, or swore. "The most profane word I ever heard him say was 'hell,'" John Boyden said. Always proud of his Foxboro roots, Boyden returned to town from time to time and delivered keynote remarks when the new high school (now the Igo School) was dedicated on June 29, 1928, which coincided with the celebration of Foxboro's sesquicentennial. Slight of stature, he had the constitution of an ox, and though treated for cancer at Presbyterian Hospital in New York for the last 15 years of his life, he endured to die of natural causes in 1972 at age 93.

Rev. Warren Bird

After Foxboro's first Baptist church was built on Elm Street in 1822, Warren Bird obtained a license to preach and became the church's first settled pastor. Five years later, he procured "a small library of little books" and established the town's first Sunday school program. In 1828, Bird curiously resigned to join the Swedenborgian church, though he remained active in the community. Years later, on March 29, 1859, he opened the first formal meeting held at Foxboro's new town house by asking "some clergyman or other person to open the meeting with prayer."

Rev. William Dudley

One might say Rev. William Dudley is rooted in the small neighborhood at the top of Quaker Hill. A 1976 Foxboro High graduate who earned a divinity degree from Gordon Conwell Theological Seminary, Dudley affirmed his roots in 1991 by returning as pastor of the Union Church of South Foxboro. Since then, he has worked faithfully to grow the church, leading a 1994 building expansion, while also taking a leadership role on many issues facing the wider community, including a divisive fight over a proposed casino on Route 1 in 2012.

Ruth Nowlan

One of the five Lewis girls—attractive, popular, and well-educated young ladies about town—Ruth Nowlan was the daughter of William R. Lewis, namesake of the former Lewis School (now the Sage School) on Mechanic Street and designer of the old fire station and Orpheum Theater. A 1936 graduate of Foxboro High School who received her degree from Colby College, she was best known as a longtime librarian at the Boyden Library, first at the old Memorial Hall location and, later, making the move to the present structure on Bird Street. Contrary to the prim, buttoned-down stereotype, however, Nowlan had personality to spare, and for years, was a fixture atop the Boyden Library's floats cruising through the annual Founders Day parade; not for nothing, she served on the organizing committee. Nowlan also was a lifelong member of Bethany Church; was active on the Republican Town Committee, Daughters of the American Revolution, and the Foxborough Historical Society; and was president of both the Foxboro Woman's Club and Foxboro Garden Club. With three daughters of her own, she was a Girl Scout leader for more than a decade. She died in June 2002 at age 83.

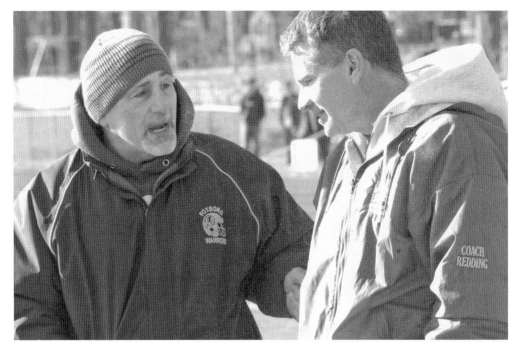

Jack Martinelli

The record does not lie. Since Jack Martinelli was named football coach in 1982, the Foxboro Warriors have won eight Hockomock championships and four Super Bowls. Inducted into the Massachusetts High School Football Coaches Hall of Fame in 2011, Martinelli's true legacy remains a positive influence on thousands of young men and women over more than three decades. And while it is true that he coached league champions, state champions, and even NFL Super Bowl champions, he also coached legions of benchwarmers—treating each with respect and dignity. Jack (left) is pictured with Mansfield coach Mike Redding.

John Certuse

There have been more successful football coaches at Foxboro High School, but none who arrived with the same sense of drama. John Certuse, the pride of Mansfield, was a squad that routinely beat its inter-town rival; in fact, Foxboro had not won a game since the series started in 1925. But after the 1944 season Certuse, now married, accepted a $300 raise to coach Foxboro, and the following November the Warriors prevailed 14-0. Certuse died of a stroke at age 53 in 1965, leaving a widow and four children and a legacy of tough teams and fair play.

Bill Rex

In the postwar era, when schoolboy sports rivaled the silver screen for entertainment value, Bill Rex was a marquee name. He was football and basketball captain at Foxboro High before heading for University of Massachusetts, Amherst, where he majored in physical education and anchored the Minuteman football team for three years. The University of Massachusetts connection proved a lasting one, as five of Rex's six children earned diplomas there. But for all his athletic accomplishments, Rex's greatest impact came later, initially as a teacher, coach, and administrator at Franklin High School, then as longtime principal at his beloved Foxboro High.

Wilson Whitty

During his halcyon days at Foxboro High School, Wilson Whitty never could have imagined that one day he would be revered in North Attleboro, a bitter Hockomock League rival. A six-foot, two-inch, 210-pound defensive standout and most valuable player of the 1963 Thanksgiving Day classic, Whitty played linebacker at Boston University and was drafted by the Dallas Cowboys. Instead, he devoted his life to education, first at Foxboro High as a teacher and assistant principal and then in 20 years as principal at North Attleboro High. Upon retiring in 2001, the school's entryway was renamed "Wilson Whitty Way" in his honor.

95

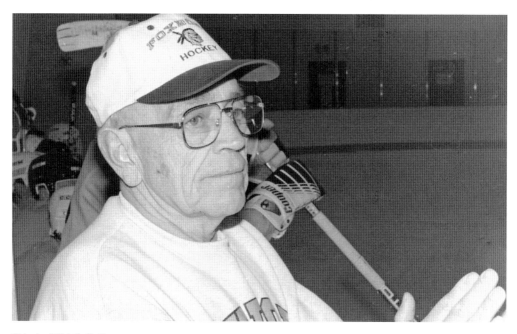

Edwin "Eddie" Guy

If it really takes a village to raise a child, Eddie Guy defined that effort for generations of Foxboro kids. Prior to his death in 2001, Guy was coach, mentor, and guardian angel through youth sports, Scouts, church school, and what became known as the Foxboro Clown Club for sick and disabled children. Fiercely proud of family and country, he was once and always a Marine, with a well-defined sense of duty and honor. He was also a father figure, instilling self-confidence through quiet encouragement and urging so many to follow their dreams.

Russell McCann

Statistics indicate people change jobs at least three times. So, it was for Russell McCann, who worked through two careers before finally finding fulfillment as a chemistry teacher at Foxboro High School. Enlisting in the Navy during World War II, McCann continued as an officer in the Naval Reserve while earning a degree from Massachusetts College of Pharmacy. While continuing his first career, he pursued his second as a retail pharmacist. When pharmaceuticals proved unsatisfying, McCann entered the classroom—and endeared himself to thousands of students over two decades.

Mabelle Burrell

Many local schoolteachers have had longer careers. Few have matched the lasting influence of Mabelle Burrell, who, in 16 years, established a classroom legacy that still resonates in East Foxboro, where the neighborhood elementary school bears her name. Hers was a roundabout route to renown. A 1908 graduate of Wheelock College, she taught in Revere for three years before exchanging vows with Charles Burrell. This prompted a lengthy hiatus from the classroom, as only single women were then considered suitable for teaching positions. In 1921, the couple settled in East Foxboro, and the Burrells raised four children as Mabelle leveraged her teaching background by winning election to four consecutive terms on the local school committee. Then in 1945, with World War II winding down, a teaching vacancy arose unexpectedly at the Pratt School, where youngsters in the first through third grades were taught simultaneously. Burrell was 59 at the time but stepped up to the plate, or rather the blackboard, confident that she could hold the fort until a permanent hire was made. Instead, what was supposed to be a temporary appointment lasted until 1961, when she finally stepped down at age 75 while continuing to substitute well into her 80s. In fact, Burrell was substituting the day when she was informed that the new 20-classroom school being built in East Foxboro would be named the Mabelle M. Burrell Elementary School in her honor. "I wanted to break down and cry," she recalled. "But the children were waiting and I had to get back to the class."

Charlie Bridgham
He took judo lessons in his 40s, started a judo school in his 50s, began skiing in his 70s, survived a heart attack and knee surgery in his 80s, and continued counseling martial arts students in his 90s. Born in Vermont, Bridgham settled in Foxboro after serving as a B-17 navigator during World War II. In the 1960s, he signed up for judo lessons at the Attleboro YMCA, mastering technique and absorbing philosophy, then founded the San Machi Judo Club in East Foxboro.

Jim Finn
In his unofficial role as consigliore to Foxboro's youth sports programs, Jim Finn has been a seasonal fixture in the lives of thousands of local youngsters and their parents. He witnessed the birth of Foxboro youth basketball, helped Foxboro youth soccer grow from 120 kids on a handful of teams to more than 2,000 participants in both spring and fall, and had a hand in the old Foxboro youth hockey program during its Bruins-inspired heyday. Were there a hall of fame for local youth sports icons, Finn would be a first-ballot inductee.

CHAPTER SIX

Local Treasures

At any time, in any age, there are a select few who, by happenstance or design, help shape and ultimately come to personify what many view as those core values the rest aspire to—a special quality which sets them apart. They have baked pies, served dinners, coached games, and led Scout meetings; raised money for churches, clubs, and organizations; chauffeured kids, kept dinner warm, and scheduled family life around sports, homework, and laundry

Some have been pillars of the community, with broad influence in overlapping spheres of corporate life; others have been just ordinary folks striving to get by while doing their best for themselves and each other. Connected by a common decency and dignity, tolerance and respect, they have had a collective impact far greater than the sum of their parts.

Some, like Tom Nalen, Charlie Maguire, and Paul Stanton, have garnered the pride and admiration that comes with a championship pedigree. Others, like Drs. Peter Haigis, Benton Crocker, and Arthur Giuliano, employed their training, skill, and compassion to care for the sick and infirm. And lastly, who can forget those special spouses whose kindness and charity provided a shining example for the rest of us—Stan and Lorraine Garland, Earle and Thalia Ferguson, Steve and Robbie Grogan, Ken and Joan Goodwin, and John and Helga Green.

As "treasures," one and all, they have given heart, vision, and hope—and reason to believe the best is yet to come. These are their stories.

Mary O'Brien-Miller
The outfit was hard to miss—red tricornered hat, spangled leotard over colonial bell sleeves, and white vinyl boots topped with blue and white stars. But while Mary O'Brien-Miller's five-year run as a New England Patriots cheerleader may have provided sizzle, it never overshadowed her day job as owner of a successful dance studio. Over a 40-year period, dancing at Miss Mary's became a rite of passage for thousands of Foxboro girls, and her annual recitals were appointment-only viewing, packing the Foxboro High auditorium each June.

Tom Nalen
Trivia question: who won back-to-back Super Bowl titles precisely a decade apart? That would be Foxboro's Tom Nalen, whose high school titles in 1987–1988 were repeated in 1997–1998 with the NFL's Denver Broncos. Shifted to center at Boston College, Nalen ended up playing 14 NFL seasons, during which he made five Pro Bowls, was a three-time All-Pro selection, and the NFL's Offensive Lineman of the Year in 2003. After his retirement, Nalen became just the 24th Bronco added to Denver's Ring of Fame inside Sports Authority.

Sarah Behn

Before Sarah Behn started dribbling a basketball, athletes at Foxboro High School may have been celebrated, but they were not celebrities. Behn changed all that. Her court presence was so obvious and her skills so dominant that she quickly gained a following of ponytailed, Converse-clad disciples who dreamed of driving the lane like Sarah. Behn set a Massachusetts high school scoring record with 2,562 points and then scored another 2,523 at Boston College before playing professionally in Europe. A mother of four, Behn now coaches at the University of Massachusetts, Lowell, having divested of a series of highly successful hoop camps.

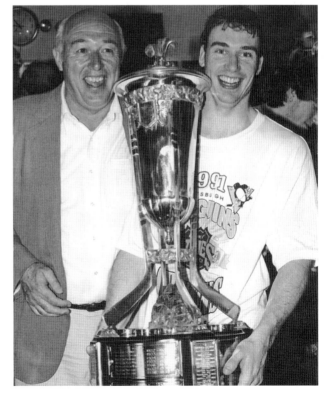

Paul Stanton

Pictured with his father, Fred, who started him skating on local ponds, Paul Stanton celebrates the 1991 Prince of Wales trophy on route to a Stanley Cup championship with the Pittsburgh Penguins. A Catholic Memorial graduate and All-American defenseman at University of Wisconsin, Madison, Stanton played 75 games his rookie year and scored his first playoff goal against the Boston Bruins before besting the Minnesota North Stars in the Cup finals. Led by hall-of-famer Mario Lemieux, Pittsburgh repeated as champs the following year.

Ron Clough

Modern-day mountain man Ron Clough spent much of his 40-year conservation career tending to local wildlife. Clough (pronounced "Cluff") retired in 2013 as forest and park supervisor at F. Gilbert Hills State Forest complex in Foxboro, which encompasses 1,050 acres and 25 miles of trails that attract hikers, mountain bikers, dog walkers, cross-country skiers, and bird watchers. Holding degrees in arborculture and forest and park management from the University of Massachusetts, Amherst, Clough was originally supervisor of the Boston Harbor Islands State Park and then transferred to the Mill Street forest headquarters in 1986.

Mead Bradner

Born in a tent in the Nevada desert where his father worked as a mining engineer, Massachusetts Institute of Technology–trained Mead Bradner spent the war years developing torpedoes for the Navy. Yet this soft-spoken research scientist, who arrived in Foxboro in 1945, hit stride when it came to outdoor pursuits. An inveterate hiker, Bradner was the unofficial ombudsman of the Warner Trail, a 30-mile woodland path winding from Canton to Cumberland, Rhode Island. While he maintained the trail and promoted its virtues, Bradner's wife, Peg, pursued a different project, spending two decades compiling an index of Foxboro news archives from 1796 to 1955.

Margaret Roberts

For nearly a half century, Margaret Roberts has delivered hope to Foxboro's bereaved and brokenhearted. Along with her husband, Bruce, and more recently son Bruce Jr., the Roberts continue to operate the funeral home established in 1939 by Bruce's father, Clifton Roberts. Although family roles and responsibilities have changed over the years, Margaret remains the primary source of solace and comfort, exhibiting a personal faith that transcends conventional religion. Whether attended by a handful of mourners or queues stretching around the block, every service receives the same attention to detail.

Margaret Weisker

A gifted embroiderer and foreign language teacher at Foxboro High School who took early retirement in 1981, Margaret "Peg" Weisker had ample time to pursue new interests. At the urging of her daughter, Kay Andberg, pictured at left, a staffer at Moosehill Wildlife Sanctuary in neighboring Sharon, Weisker began volunteering at the 2,000-acre refuge. She took to her new duties with aplomb and, at age 76, was named Massachusetts Audubon's Volunteer of the Year in 2003.

Don Ahern

So long as people wanted to dance, Don Ahern would play. A bandleader who entertained thousands during his long career, he is best remembered, trumpet in hand, as the head of the Don Ahern Orchestra, which performed regularly at the King Philip Ballroom (now Lake Pearl Luciano's) for many years. Having mastered cornet in grade school, Ahern spent World War II entertaining troops with the Army Ground Forces Band. After the war, he regularly backed such headliners as Doris Day, Vaughn Munroe, and Jimmy Durante, before forming his own orchestra.

Mark Small

Classical guitar virtuoso Mark Small has written rock and pop songs, jazz compositions, orchestral pieces, even sacred works performed by the Mormon Tabernacle Choir. However, he is better know for two collaborations—the Small-Torres Guitar Duo and the Small-Clemente Duo—which released seven CDs of sacred and classical music. A serious musician equally serious about his faith, Small has long been active in the Church of Jesus Christ of Latter-Day Saints, serving as bishop of the Foxboro Ward from 2003 to 2009, where he ministered to the 300-member congregation in matters both spiritual and temporal.

Kurt Bacher

Kurt Bacher always had tremendous ears, strictly in a musical sense. A saxophonist and multiple woodwind player (who also plays flute, clarinet, and oboe), Bacher stood out even among the acclaimed musicians at Foxboro High School. Now living in Harlem, Bacher is a protégé of jazz great Wynton Marsalis, with whom he swapped solos at the Essentially Ellington Jazz Festival. Beyond composing and arranging, Bacher teaches woodwinds in the New York schools, but retains a soft spot for his alma mater—stopping by Foxboro High if passing through Boston or visiting family.

Krisanthi Pappas

Her first name means "golden flower" in Greek. And as a vocalist and musician, Krisanthi Pappas has lived up to the imagery. A jazz, cabaret, and pop entertainer who's called Foxboro home for two decades, Pappas averages 150 performances a year at jazz venues, singer-songwriter series, festivals, resorts, clubs, and private events across New England. Musical director at Foxborough Universalist Church, she teaches piano, music theory, and vocal performance and has released five CDs, including a Christmas album and a live disc recorded at the Footlighters Theatre in Walpole.

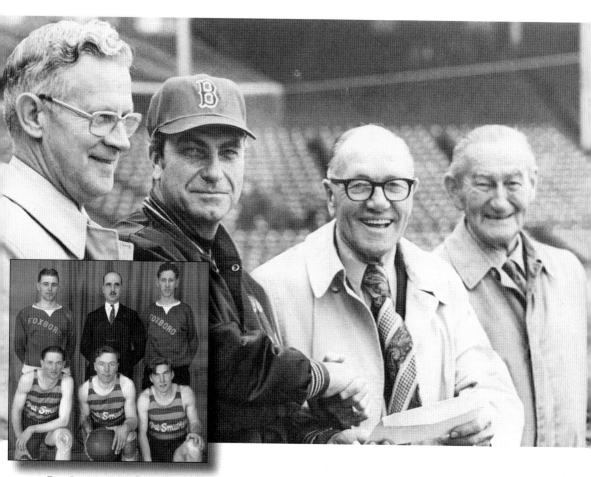

Pat Smith

Long before the arrival of the New England Patriots in 1970, Foxboro had a proud history of sporting endeavors, and Pat Smith authored much of it. A talented athlete in his own right, Smith really made his mark as an organizer, or more accurately as a promoter. And during the Depression-era, at a time when semiprofessional sports was a big draw in small towns, the Pat Smith All Stars put Foxboro on the map. The basketball All Stars played upstairs in the Grange Hall on Bird Street, where they astonished visiting teams by heaving long shots up through the rafters and into the hoop. In the vintage photograph, Smith is seen kneeling in he center, clutching the ball. After the war, as the All Stars wound down, Smith moved on to his next big thing, organizing perennial trips to Fenway Park for Foxboro youngsters. For many kids, it was the first, and only, chance to see their beloved Red Sox play—and no one ever paid a dime. Leveraging local connections, Smith funded the mid-summer excursions by putting the arm on local businesses until all costs were covered, including bus ride, chaperones, peanuts and Cracker Jack, and game tickets. Given his athletic pedigree and larger-than-life persona, it is hardly surprising that Smith's favorite cause was the Jimmy Fund. Long before the Pan-Mass Challenge, Ride for MS, Relay for Life, and the overall corporatization of America's nonprofit sector, Pat Smith championed the Jimmy Fund simply because if felt right. Over the span of 29 years, he raised more than $125,000, big money for the time, at charity events, most notably an annual auction on the common supported by contributions from the business community. In the photograph above, a beaming Smith visits Fenway and presents a check to Red Sox manager Darryl Johnson, while Foxboro's Carl Kusch, left, and Homer Nevers look on. Pat Smith finally hung up his own cleats in 1978 at age 75. At his subsequent passing, he was honored as a true legend within a community of legends.

William McAlister

He was 43, an electric company boss with a passion for harness racing, on Labor Day 1947 when Bay State Raceway opened its doors. With his four sons and wife, Ruth, looking on, Foxboro's William McAlister drove George Sweetman's chestnut gelding, named Paid, to victory in the first race at the new Route 1 track. Seen in the winner's circle afterwards, the winning time was 2:18-3/5. Years later, Sweetman gave Paid to McAlister, who kept him until the horse's death in 1953.

Tom O'Leary

Tom O'Leary never played the Professional Golfers' Association circuit. But he was a perfect choice as club professional when a group of local dreamers improbably developed a golf course off Walnut Street in the 1950s. Pictured second from the right, O'Leary was 13-time champion at Sharon Country Club, a course laid out in 1898 on his grandfather's farm, which his father groomed for 35 years as head greenskeeper. With that kind of pedigree, it is no wonder young Tom aspired to a career on the links.

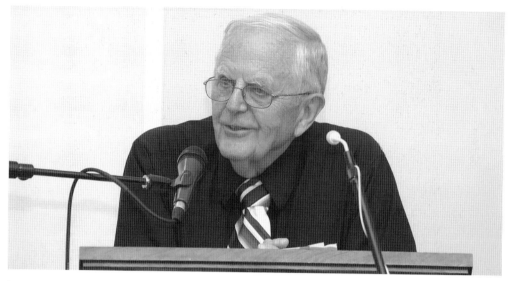

Jack Authelet

When it comes to defining, packaging, and promoting the "Foxboro brand," no one has done it better than Jack Authelet. A lifelong resident who sports a "Foxbro" license plate, Authelet has contributed to the hometown newspaper for four decades, chronicling the joys and sorrows of everyday life, weighing in on pivotal issues facing the community, and providing townspeople information and context needed to make sound decisions. In his overlapping role as town historian, Authelet has breathed life into 250 years of local history through newspaper articles and meticulously researched historical books.

Mary Souza

Like fine cognac, Mary Souza has gotten better with age, assisting the town's Meals on Wheels program and completing her fifth term on the Foxboro Housing Authority while in her 90s. Active in elder affairs upon arriving in Foxboro in 1972, Souza became the first coordinator of the old senior drop-in center, served in the Massachusetts Silver-Haired Legislature, was affiliated with Hessco Elder Services, was an ombudsman at the Doolittle Home, and sang with the Serenading Seniors chorus—all complementing her 22-year run on the housing authority.

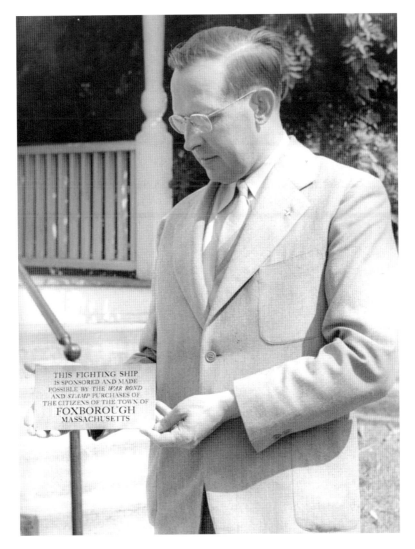

THIS FIGHTING SHIP
IS SPONSORED AND MADE
POSSIBLE BY THE *WAR BOND*
AND *STAMP PURCHASES* OF
THE CITIZENS OF THE TOWN OF
FOXBOROUGH
MASSACHUSETTS

Corrie Fuller

Officially, Corodon S. "Corrie" Fuller was secretary and treasurer of the Foxboro Company, a school committee member from 1929 to 1944, a neighborhood air raid warden, and wartime head of the town's Defense Savings Committee. But that just scratched the surface of his numerous above- and below-the-radar activities. During the war, Fuller oversaw much of the home-front fundraising activity, which included a payroll savings plan at the Foxboro Company, war stamp sales in local schools, and seven official war bond drives—all dutifully tracked by a large sign on the town Common. Under Fuller's guidance, these drives collectively raised over $3 million, facilitating the purchase of two PT boats and 10 P47 Thunderbolt fighter planes. In the photograph, Fuller cradles a commemorative plaque that was affixed to one of the PT boats. But it was his multifaceted work behind the scenes that really cemented Fuller's place in local history. Quiet and unassuming, he was a skilled photographer who specialized in moving pictures. He was also an intrepid traveler, creating exotic travelogues of places visited with his wife, Helen. But his most meaningful, and memorable, brainchild may have been "Since You Went Away," a film project that recorded all the events that occurred in Foxboro during World War II. The final version was a heart-warming feature when screened at parties held for returning servicemen and women after the war, including the one in honor of his son Ben Fuller, who had been a German prisoner of war.

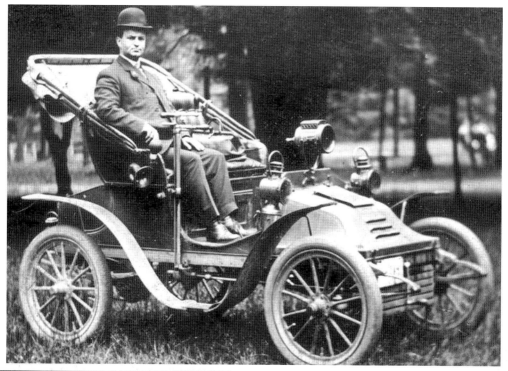

Dr. Peter Haigis

Arguably Foxboro's first physician making house calls by automobile, Dr. Peter Haigis arrived in Foxboro in 1904, toting a medical degree from Boston University. He eventually lived and practiced in a sprawling home at the corner of Central and Liberty Streets (and since moved to the corner of Central and Clark Streets). Haigis's fondness for cars was well known. During the town's sesquicentennial parade in 1928, he drove a decorated coupe with a large stork on top of the radiator. In the stork's bill was a sling containing a baby doll.

Dr. Benton P. Crocker

Benton Pulsifer Crocker, MD, holds the distinction of being Foxboro's first, and perhaps its only, town doctor, paid by the town to care for patients without means. Born in Hyannis, he came to Foxboro in 1894, and quickly, he established a thriving practice. He was characterized as a "typical small-town physician," making daily calls, attending patients day or night, and establishing a broad clientele that had been in his care since childhood. He was a particular favorite of Foxboro's older residents and provided free care to residents at the Doolittle Home.

Dr. Arthur Giuliano

Back in 2003, when Dr. Arthur Giuliano's son Christopher joined his Central Street pediatric practice, he already had been a local institution for 27 years. Now closing in on four decades and accustomed to caring for second-generation children, Giuliano has developed a clear understanding of his calling. "There is so much to pediatrics besides book knowledge," Giuliano observed in 2003. "To truly be an effective physician you have to have those intangible people skills that show genuine caring and a desire to help."

Mary Callahan

Paid $8 a month as a 17-year-old trainee in the Cadet Nurse Corps during World War II, Mary Callahan was consoled by some great benefits, like free tuition, free uniforms, and a guaranteed job upon graduation. Hired by the Contagious Disease Hospital in Brighton at the height of the polio crisis, Callahan later relocated to Foxboro, where her bona fides included the first nurse manager at the old Foxboro Area Health Center in 1973. Affiliated with Norwood Hospital, the center brought high-quality care to Foxboro back when physicians still made house calls.

Ken and Joan Goodwin

Ken and Joan Goodwin had five children of their own—
and probably another 500 on retainer. He was a Marine
during the Korean War who worked for the local
housing authority. She drove a school bus and relished
perennial appearances aboard the West Foxboro
Mother's Club "horribles" float in the annual Fireman's
Parade. But their shared passion was youth sports,
and from the 1970s through the 1990s, no one worked
harder to improve that experience. A year before his
death in 2006, Foxboro midget football named the field
house at Ernie George Field in Ken Goodwin's honor.

Steve and Robbie Grogan

Of the many New England Patriot players who put down
roots in Foxboro, Steve and Robbi Grogan were among
the most enduring and endearing. Native Kansans who
raised three boys in a home built down the street from
then-coach Chuck Fairbanks, the Grogans were local
celebrities who never put on airs. A role model on the
field and off, Steve Grogan used his influence on behalf
of the Hockomock YMCA, Wrentham State School, and
Easter Seals while Robbi focused her energies on the
Kennedy-Donovan Center.

Earle and Thalia Ferguson
Products of their environment, Earle and Thalia Ferguson were raised in South Foxboro when agriculture was still a way of life. Married in 1952, they were long active at the Union Church before collaborating on another special ministry, the Foxboro Community Farm Stand project, which raises tens of thousands of dollars each year for charity. With his love of farming, Earle tended on-site crops while Thalia has overseen administration and scheduling. "It's our mission to Foxboro," she observed in 2010. "You send missionaries out into the world. We're missionaries right here."

Stan and Lorraine Garland
Mainers who relocated to Foxboro in 1977, Stan and Lorraine Garland took their civic involvement seriously, and over the next 23 years, they increasingly accepted personal responsibility for aiding the community's most vulnerable. That mission was shattered in December 2000 when the couple was killed in a highway crash while returning from a holiday party in New Jersey—a week after Lorraine was honored as a finalist for Foxboro Rotary's inaugural Service Above Self Award. Both were in their early 50s at the time.

Johnny Barros

A superfan long before the term was ever coined, Johnny Barros was at Boston Garden when "Havlicek stole the ball," at the Country Club in Brookline when Julius Boros captured the 1963 US Open, and had skybox seats for the famous 29-29 tie between Harvard and Yale. Pictured on his 80th birthday, Barros was a standout athlete in high school whose Chestnut Street home was a virtual sports museum. In later years, Barros declared Joe DiMaggio the best professional ever—and anointed high schoolers Connie Flanders and Sarah Behn as in a class by themselves.

Charlie Maguire

Massachusetts cross-country champion in 1969, Charlie Maguire remains the top distance runner in local history. This fleet-footed Eagle Scout found even greater glory at Penn State, where he was 1973 NCAA six-mile champion—separating himself from the field of runners in brutally hot and humid conditions in Baton Rouge, Louisiana. In 1974, Maguire was an All-American three-miler and, later, competed internationally with US Track & Field. Earning his bachelor's and master's degrees at Pennsylvania State University, he became a teacher and private tutor before returning to Foxboro, where he died in 2006 at 53.

Bud and Flossie Smith

One year apart at Foxboro High School, Everett "Bud" and Florence "Flossie" Smith never dated. "What? Date a junior?" he snorted decades later. But the couple was well matched, gathering their six kids for scripture and a word of prayer before sending them off each morning. In their retirement, Bud and Flossie emerged as diehard rooters at Foxboro High School athletic events, particularly girls' basketball and soccer games, and often mentored young athletes over spaghetti dinners at their Chestnut Street home.

John and Helga Green

Moving to their East Street home in 1947, the late John and Helga Green knew the place had potential, but it just required a little imagination. They methodically improved the property while raising three sons, and in the process, they developed "Green Acres," a recreational park that became a source of enjoyment and income for its owners. Amenities included a softball field, picnic tables, swings, seesaws, slides, tetherball and volleyball courts, parking for 100 cars, and most memorably a zip-line contraption that anxious youths clung to while whizzing down at breakneck speeds.

Constantine Penkos

Known as "Connie" to his wide circle of friends, Constantine Penkos's half century in Foxboro was characterized by a devotion to the Boyden Library, mostly as founder of the Friends of Boyden Library Foundation, which organized fundraising efforts for the construction and ongoing support of the present library on Bird Street. A Coast Guardsman during World War II, he spent his last years of life at Doolittle Home, where he could gaze out of his window at his beloved Boyden Library across the street.

Alan Hanna

To appreciate what made Alan Hanna tick, one had to go knocking on heaven's door. A lifelong resident who worked at the Foxboro Company, Hanna lovingly maintained the iconic steeple clock at Bethany Congregational Church. He learned the craft from his father, Archie (see page 26), and passed it on to his son-in-law. Still a dominant downtown landmark thanks to Hanna's mechanical ministrations, the 160-year-old works are powered by a hand crank and copious applications of elbow grease.

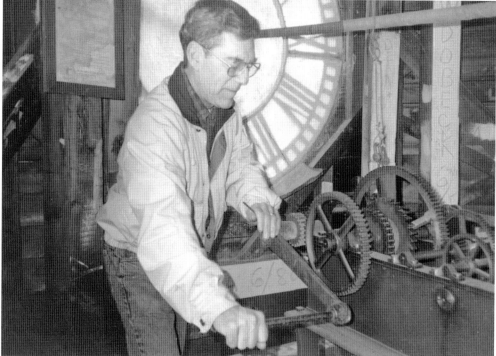

CHAPTER SEVEN

Profiles in Courage

United through adversity, some of Foxboro's most memorable citizens have endured long odds and considerable hardship facing challenges defined their respective generations or personal circumstances—sickness, world conflict, and social upheavals.

As one would expect, many displayed unflinching courage while in uniform. Cliff Curry received the Silver Star for valor during World War II, as Josephine Miller was serving in the Women's Marine Corps Reserve; Foxboro-born Sanford S. Burr organized and led a Civil War cavalry unit while attending Dartmouth College; and Walter Scott West, father of longtime town treasurer Hugh West, remains the lone Foxboro recipient of the Congressional Medal of Honor.

Others, like Brenda and Sandy Aulis, "Butch" Coyne, and Paul Doherty, rebounded from medical conditions that threatened their very survival. Priscilla Bartlett and Marion Daniels nursed combat casualties during two world wars. Not all of the profiles lived happily ever after. Jeff Parker and Jennifer Haskins were both 25 when they succumbed to the illnesses that eventually consumed them, and Lawrence Foster never returned home from the battlefield in World War I.

Arguably the most inspiring tales involves those who endured incredible privation in order to secure a better future. Alma Shahabian escaped the Armenian genocide and was sold into slavery before making her way to a new life in Foxboro; Ewa Jedrychowska survived both Nazi and Soviet occupation of her native Poland to become a fixture at St. Mary's Church; Rev. Frank Cary, like his father, a missionary working in Japan, outlasted a Philippine internment camp after being seized and imprisoned by the Japanese during World War II. These are their stories.

Rev. Frank Cary

Imprisoned in a Japanese internment camp during World War II, Rev. Frank Cary discovered the literal meaning in the Our Father's earnest plea: "Give us this day our daily bread." Born in Foxboro to missionary parents, he was the grandson of Otis Cary, first president of Foxborough Savings Bank (see page 14), and had spent much of his childhood in Japan before graduating from Amherst College (class of 1911) and Oberlin Seminary. Cary returned to Japan as a missionary doing church, student, and general religious work, and, in September 1941, was transferred to the Philippines mission at Davao, Mindanao. He was taken prisoner there on December 20, 1941, just 16 days after the Pearl Harbor attack, and then sent to the Santo Thomas internment camp in Manila in December 1943. Because of his ability to speak Japanese, Cary was invaluable to his captors as interpreter. With this, however, came the stress of dealing with Japanese commanders while trying to secure better treatment for his fellow prisoners. Ironically, while Frank Cary had been imprisoned his son Otis Cary, also fluent in Japanese, was a Navy lieutenant interrogating Japanese prisoners of war on Saipan. Cary's last official job as interpreter came on February 3, 1945, after the United States retook the Philippines and surrounded the Santo Thomas camp; he carried terms of surrender to Japanese officers caught inside by the sudden appearance of American troops. Over the course of four years in captivity, the large-framed cleric lost a tremendous amount of weight, suffering from tropical ulcers and a condition similar to beriberi caused by a lack of protein in the diet. Cary was returned to Boston on May 22, 1945, to reconnect with his 89-year-old mother living in Bradford, Massachusetts. But his faith inevitably took him back to Japan to minister to his captors, and in 1960, he returned to pastor a small congregation in western Massachusetts.

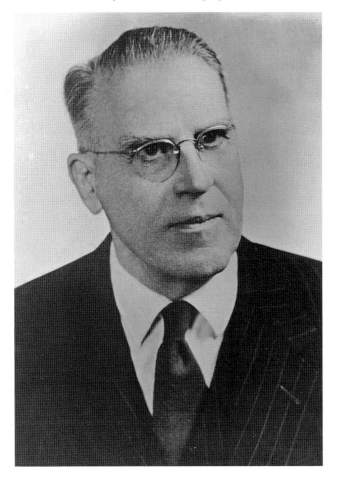

Cliff Curry

A World War II veteran who celebrated his 19th birthday in Africa, Cliff Curry was battle tested in December 1945 when his recon unit probed Belgium's Ardennes Forest at the start of the Battle of the Bulge. Withstanding the onslaught, Curry's eight-man squad began pushing deeper into Germany and, at one point, encountered an enemy tank, which opened with machine guns. Five Americans fell, four dead. Instinctively, he began laying down covering fire so the dead and wounded could be retrieved—an act of heroism, which earned Curry the Silver Star.

Josephine Miller

Pictured as a sergeant in the Women's Marine Corps Reserve during World War II, Josephine Miller remains spry, steadfast, and forever faithful well into her 90s. Active at American Legion Post 93, she distributes poppies made by disabled vets on Veterans Day, makes hundreds of lapel ribbons for POW-MIA Recognition Day, and distributes American flags to veterans' graves on Memorial Day, which is also when she places a ceremonial wreath on the town's World War II memorial.

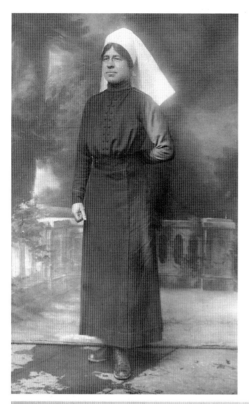

Marion Daniels

Born at Normandy Farms on West Street, Marion Daniels had her nursing degree when World War I exploded across Europe. As a result, long before the United States declared war on Germany, Daniels already joined a Harvard Medical School unit providing medical services for the British Expeditionary Forces. Arriving in France in December 1916, she worked the next 18 months in a hospital zone between Paris and LeHavre. Returning stateside in March 1918, she was assigned to Camp Devens in Ayer, where wounded doughboys were sent for treatment.

Priscilla Bartlett

Priscilla Bartlett was trained in child care. But during World War II, she joined the Navy and was assigned to the Hospital Corps, treating combat casualties with broken bodies. Recalled to duty during the Korean War, she was assigned to the Chelsea Naval Hospital and frequently brought patients home to Foxboro for the weekend, a brief respite from the hospital routine. Bartlett later joined the staff at the Veterans' Hospital in West Roxbury where she spent the remainder of her life, still helping veterans.

Shirley Mott

Shirley Mott's first exposure to cancer came long before her own diagnosis by attending the funerals of afflicted family members. A Central Street florist and longtime organist at the Foxborough Universalist Church, Mott eventually succumbed to the disease. But she fought it with all her strength over 14 years, enduring six surgeries, numerous radiation and chemotherapy treatments, and even genetic testing at Dana Farber Cancer Institute. In 1994, four years before her death, Mott's courage in the face of adversity prompted Southwood Hospital to name her Survivor of the Year.

Paul Doherty

Seen at left enjoying a coffee break with fellow officer Billy Graham and firefighter Les Goodwin, Paul Doherty always will be remembered for his courage recuperating from a 1994 snowblower accident, which severed four fingers on his right hand. It was a gruesome injury initially thought career ending since police officers had to qualify in marksmanship each year. Undeterred, Doherty practiced shooting left-handed for hours on end. Three months later, he took the test and scored 98—higher than his right-handed score the previous year. "I guess I should have been shooting left-handed all along," Doherty quipped.

Lawrence W. Foster
More than a century after his death, the name Lawrence W. Foster still resonates in Foxboro thanks to a 1919 decision to name the town's American Legion post in his memory. Foster was one of four from Foxboro to lose their lives during World War I. Assigned to an ambulance crew, he died from shrapnel wounds on October 23, 1918, somewhere north of Verdun and was buried in the Argonne American Cemetery.

Walter Scott West
Born in Bradford, New Hampshire, and buried at Rock Hill Cemetery, Walter Scott West is recognized as Foxboro's lone Congressional Medal of Honor winner. Father of longtime town clerk-treasurer Hugh West, the Marine Corps private was cited for "extraordinary bravery and coolness" on a three-hour raid to disrupt enemy communications at the Spanish-held port of Cienfuegos, Cuba, during the Spanish-American War. West was in good company; 51 other combatants also received the Medal of Honor for their actions that day—almost certainly making it the most-decorated engagement in US military history.

Sanford S. Burr

Born in Foxboro on October 11, 1839, Sanford S. Burr seemed destined to leave his mark on the world. But few could have realized the Foxboro native would be remembered for his association with one of the most colorful chapters of the Civil War. Burr was enrolled at Dartmouth College when war broke out between North and South. Popular, engaging, and oh-so-persuasive, he helped form a drill company among fellow undergraduates. Then, when Pres. Abraham Lincoln issued a first call for volunteers, Burr organized what became known as the "Dartmouth Cavalry" or "College Cavaliers," a company recruited from Dartmouth, Norwich, and Bowdoin students and, later, attached to the 7th Rhode Island Cavalry. Against the advice of Dartmouth president Nathan Lord, Burr's horsemen departed Hanover, New Hampshire, on June 18, 1962 (just before the start of final exams), for what might be described today as a real-life work study, a three-month gallop through the Civil War. If Burr's wartime adventure proved uneventful, the rest of his life was not. Graduating in 1863, he studied law and passed the bar three years later. But instead of hanging out a shingle, Burr joined a Boston furniture manufacturer and obtained several patents for folding beds, crib tables, and other multiuse items. Eager for new challenges, he relocated to Chicago in 1879 and contracted with A.H. Andrews & Co. to manufacture his patented "Burr Beds." He settled in Winnetka, an upscale suburb north of Chicago, and quickly established himself as a civic leader, serving as the first village president in 1888 and, later, as first president of the Winnetka Library Board. Burr died on May 27, 1901, but his daughter Carrie Burr Prouty followed in her father's footsteps as library board president, serving in that capacity for 25 years. She was renowned in Winnetka as a "favorite daughter" of sorts, recognized for her sweet personality and good works.

Ewa Jedrychowska
Ewa Jedrychowska was nine months old in August 1939, weeks before the German blitzkrieg, when her Polish father was seized by Soviet troops and dispatched to Siberia. Released after Germany attacked Russia, he made his way to England, but Jedrychowska, her mother, and two brothers, remained in Poland for the war's duration. Afterwards, they fled aboard a Swedish ship, reunited with her father, and settled in Canada and then moved to Foxboro in 1959. She hoped to become a hospital administrator but was hired at the Foxboro Company. A devout Catholic, Jedrychowska never married. She also never lost her Polish accent.

Alma and Archie Shahabian
Archie and Alma Shahabian survived the Armenian genocide to build a new life in Foxboro, far removed from the ordeal. Alma's experiences were especially harrowing. Sold twice into slavery and her father and two brothers executed, she was released to British authorities after World War I and somehow connected with a 56-year-old uncle living in Foxboro. Arriving in 1923, Alma married Archie Shahabian a year later, and through hard work and frugality, they carved out a foothold that was passed on to the next generation. Both are buried at Rock Hill Cemetery.

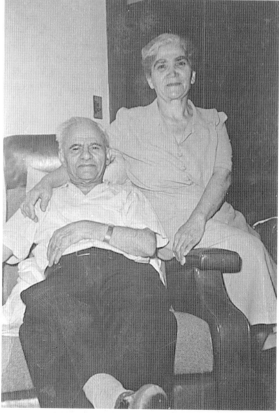

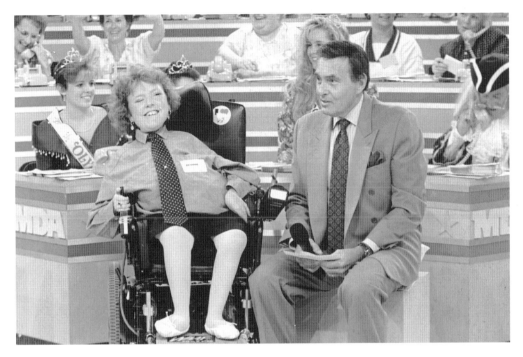

Jennifer Haskins

For television viewers during the 1970s and 1980s, Jennifer Haskins was the face of Labor Day. Afflicted with muscular dystrophy, Haskins was a pint-sized ambassador to audiences watching the annual telethons. She was plucky and unpretentious, winning the hearts of both viewers and celebrities who appeared on the broadcasts and became especially close to Chet Curtis and Natalie Jacobson, who attended her 1989 graduation at Foxboro High School. Haskins earned a degree from the University of Massachusetts and worked briefly as a teacher's aide at the Igo School before succumbing to the disease in June 1996, at age 25.

Aulis Twins

Brenda Todd and Sandra Gould are in their 60s now, which was nearly unthinkable in March 1962 when they became the first identical twins to have identical open-heart surgeries on the same day. Dubbed the "Miracle Twins," Brenda and Sandy (Aulis) were playing Chinese checkers days after surgery and were back to school five weeks later. The procedures, performed at Boston's Children's Hospital, catapulted the 11-year-old twins into national prominence as enthusiastic poster children for the American Heart Fund, who later visited the White House to meet Lady Bird Johnson.

Jeff Parker

Jeff Parker sported an oversized frame with a heart to match. Too big for midget football in middle school, he played lineman at Foxboro High but left his mark on the wrestling mat. All-everything his senior year, Parker went 40-0 on route to state and New England titles and, later, became wrestling captain at the University of Buffalo, winning 27 matches his senior year. But even Parker could not beat the melanoma that ravaged his burly frame and eventually claimed his life at 25 in May 2010. "He was just a good person," recalled Foxboro High School coach Brian Gallagher.

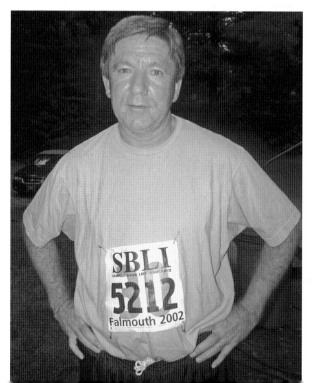

Butch Coyne

Bartley "Butch" Coyne, then 48, was not out to set records in August 2002 when suiting for the annual Falmouth Road Race. Simply running was a personal triumph for this 1972 Foxboro High graduate who, in February 2000, nearly died awaiting a heart transplant. Coyne's ordeal was compounded by the death of his son, Bartley Coyne III, in a car accident just before doctors had diagnosed his own condition. Thus, while Butch Coyne desperately needed a new heart, his son's was already beating in the chest of a 41-year-old New England Patriots fan.